Simple Drawing

Step By Step

by Kasia Dudziuk

ARCTURUS

ARCTURUS

This edition published in 2024 by Arcturus Publishing Limited
26/27 Bickels Yard, 151–153 Bermondsey Street,
London SE1 3HA

Edited by JMS Books llp with Joe Harris
Layout by Chris Bell
Illustrations by Kasia Dudziuk

ISBN: 978-1-3988-3740-9
CH004664US
Supplier 29, Date 1123, PI 00005459

Printed in China

Contents

Wild Animals

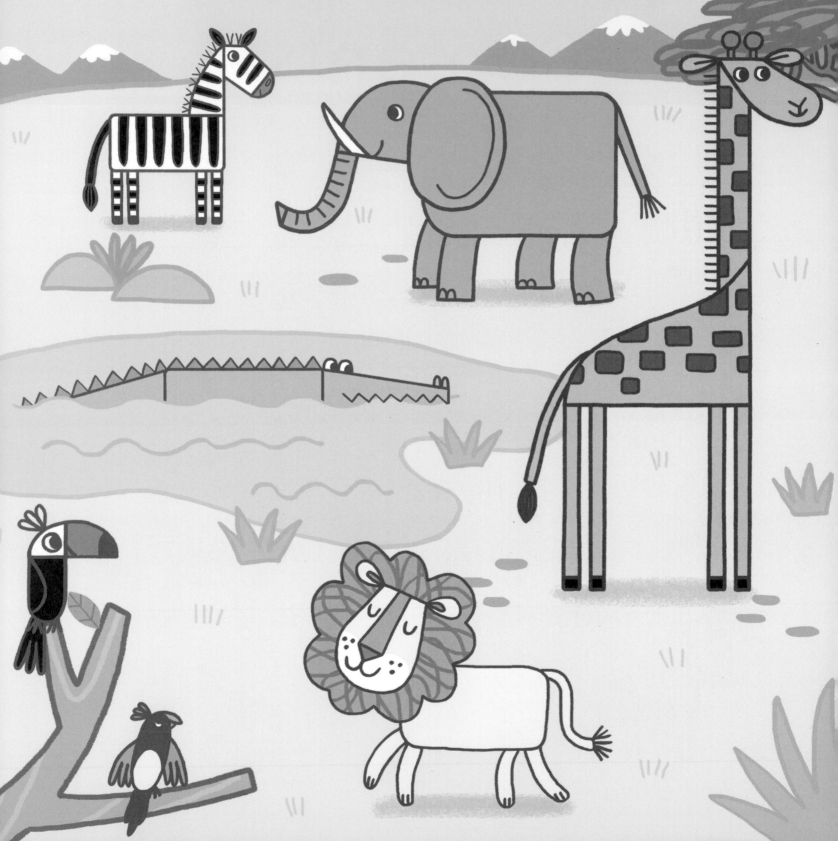

Let's draw a zebra.

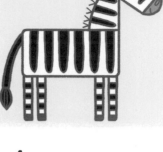

1 Here are his body and neck.

2 Now add his head and nose.

3 Don't forget his ears, legs, and long tail!

4 Give him a face and some black stripes.

Practice drawing some zebras here.

Can you draw a lion?

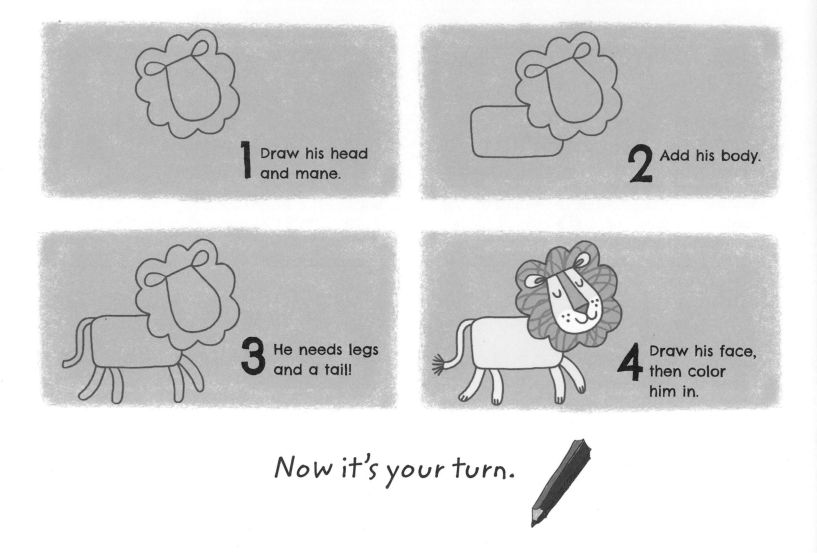

1 Draw his head and mane.

2 Add his body.

3 He needs legs and a tail!

4 Draw his face, then color him in.

Now it's your turn.

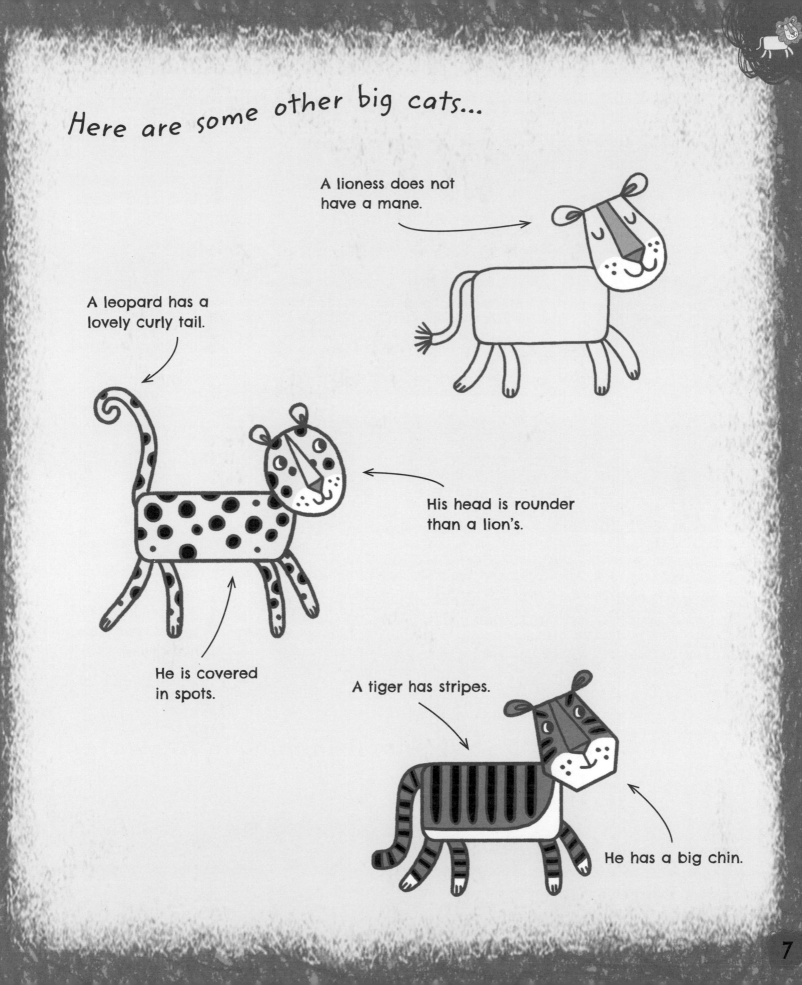

Here are some other big cats...

A lioness does not have a mane.

A leopard has a lovely curly tail.

His head is rounder than a lion's.

He is covered in spots.

A tiger has stripes.

He has a big chin.

Now let's try a crocodile.

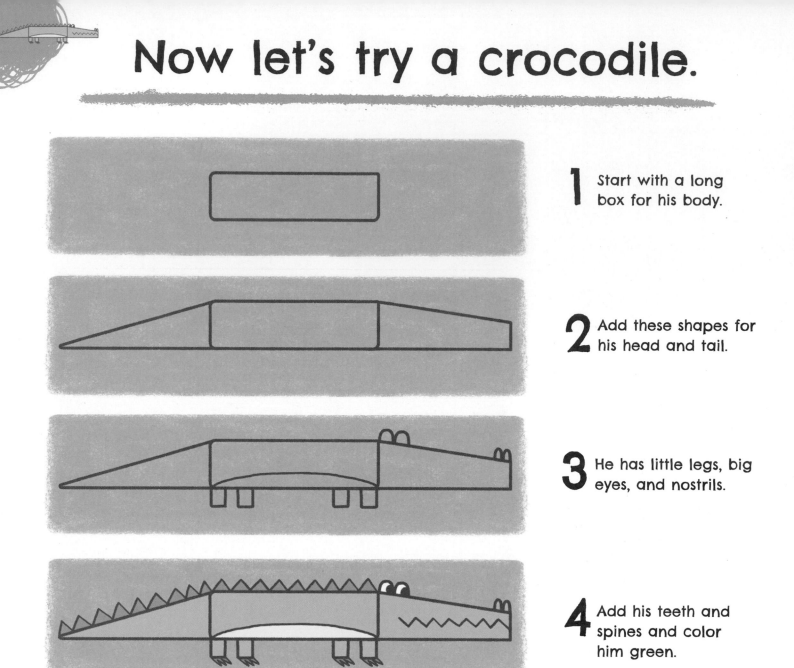

1 Start with a long box for his body.

2 Add these shapes for his head and tail.

3 He has little legs, big eyes, and nostrils.

4 Add his teeth and spines and color him green.

This is how you show him swimming in the water.

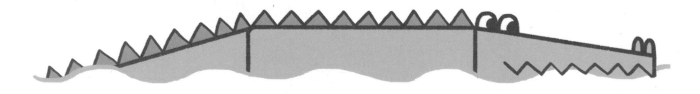

Draw some crocodiles in the river.

Draw a pretty parrot.

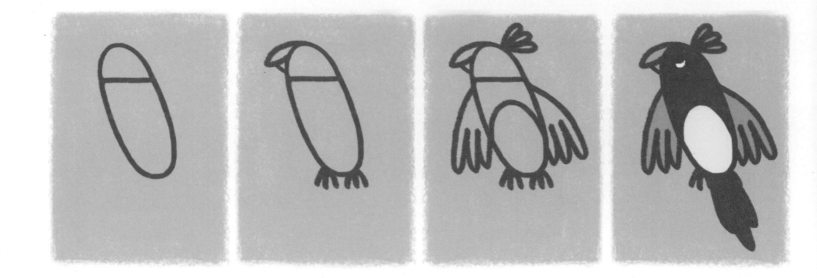

1 Draw her body and head.

2 Now she has a beak and feet.

3 She needs wings and feathers!

4 Add her eye and tail. Make her very colorful.

Now you have a try.

Draw some parrots in the tree.

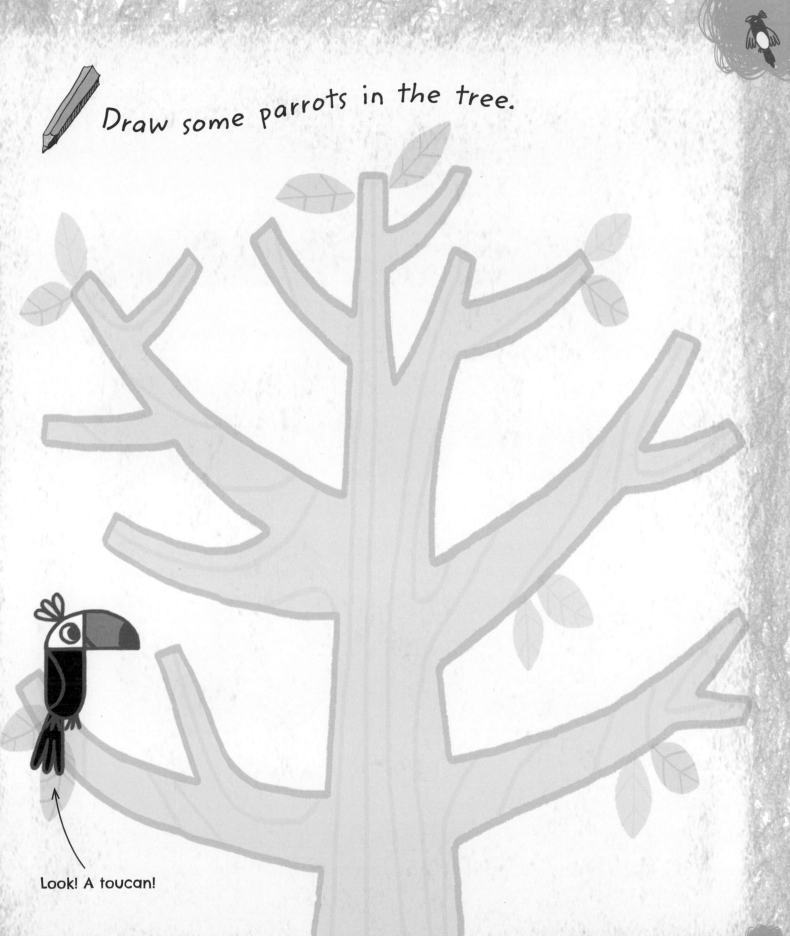

Look! A toucan!

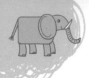

Let's draw an elephant.

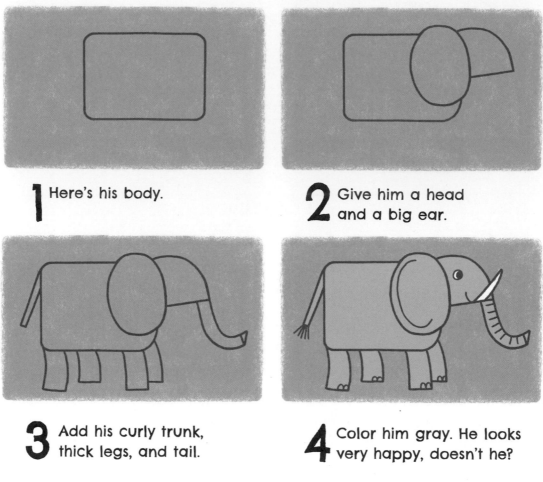

1 Here's his body.

2 Give him a head and a big ear.

3 Add his curly trunk, thick legs, and tail.

4 Color him gray. He looks very happy, doesn't he?

Try drawing your own elephant!

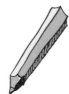

Draw a line of elephants with a baby at the back.

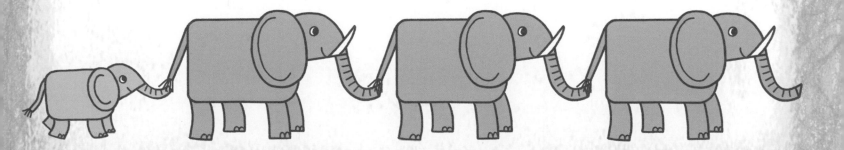

How about a tall giraffe?

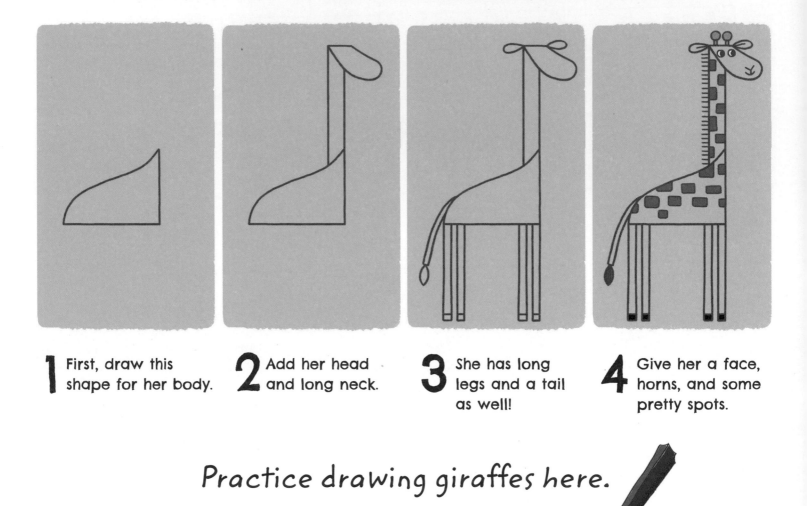

1 First, draw this shape for her body.

2 Add her head and long neck.

3 She has long legs and a tail as well!

4 Give her a face, horns, and some pretty spots.

Practice drawing giraffes here.

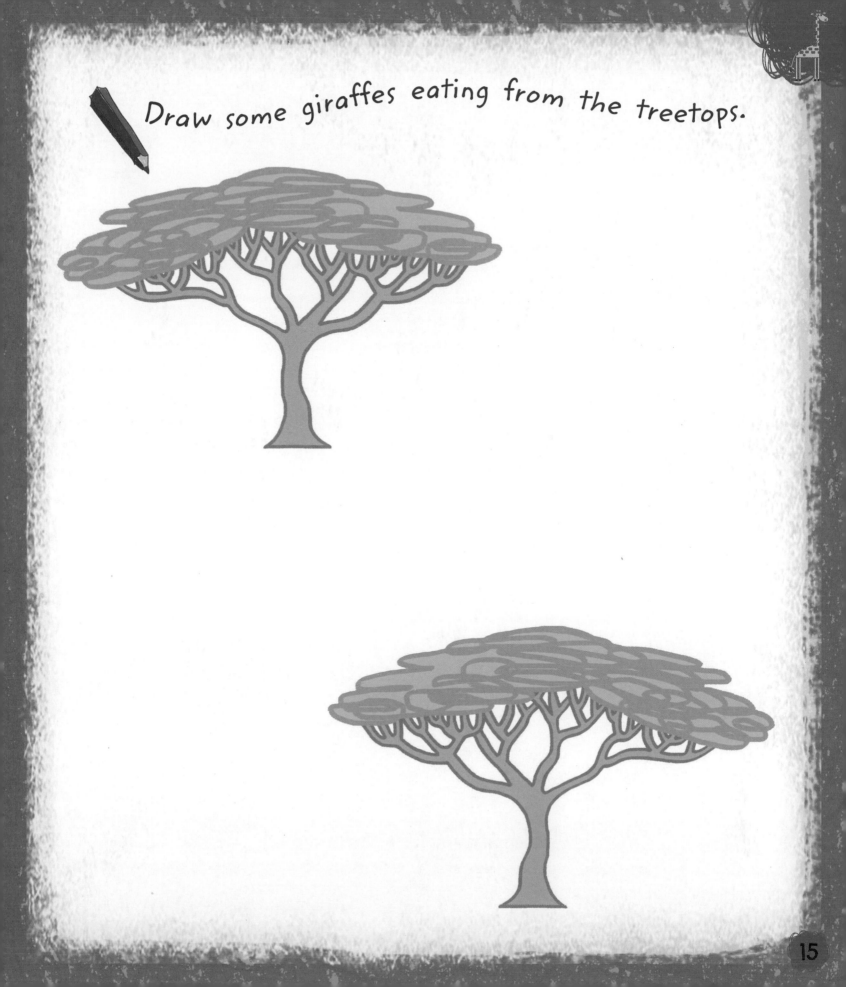

Draw some giraffes eating from the treetops.

Things That Go

Can you draw a bicycle?

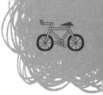

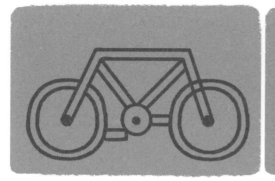

1 It has some big circles for wheels...

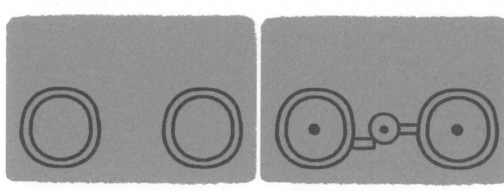

2 ...and a little circle for the pedals.

3 Can you draw the frame?

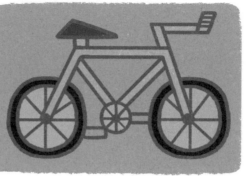

4 Add the handlebars and seat and color it in.

Now you have a try!

What about a train?

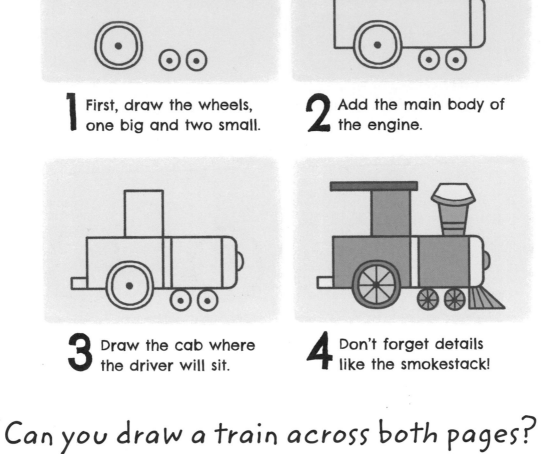

1 First, draw the wheels, one big and two small.

2 Add the main body of the engine.

3 Draw the cab where the driver will sit.

4 Don't forget details like the smokestack!

Can you draw a train across both pages?

The train will need some carriages...

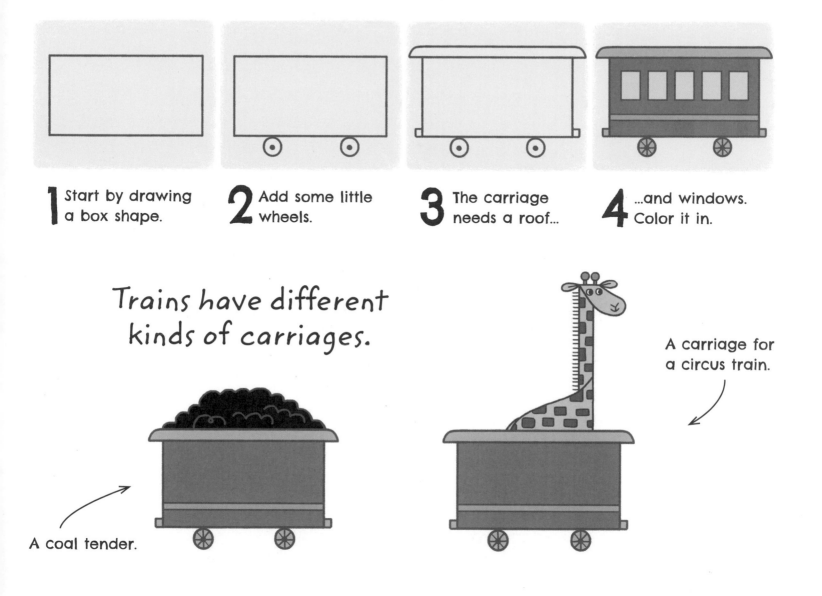

1 Start by drawing a box shape.

2 Add some little wheels.

3 The carriage needs a roof...

4 ...and windows. Color it in.

Trains have different kinds of carriages.

A coal tender.

A carriage for a circus train.

Choo-choo!

Let's try a hot-air balloon.

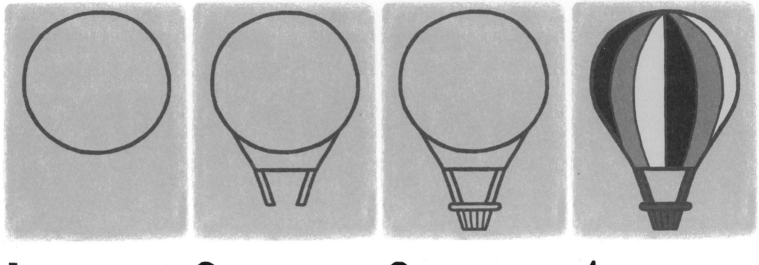

1 Begin with a simple circle.

2 Draw in the ropes...

3 ...and a basket for the passengers.

4 Hot-air balloons are brightly colored!

Can you draw one as well?

Draw some balloons in the sky.

Draw a sailing boat...

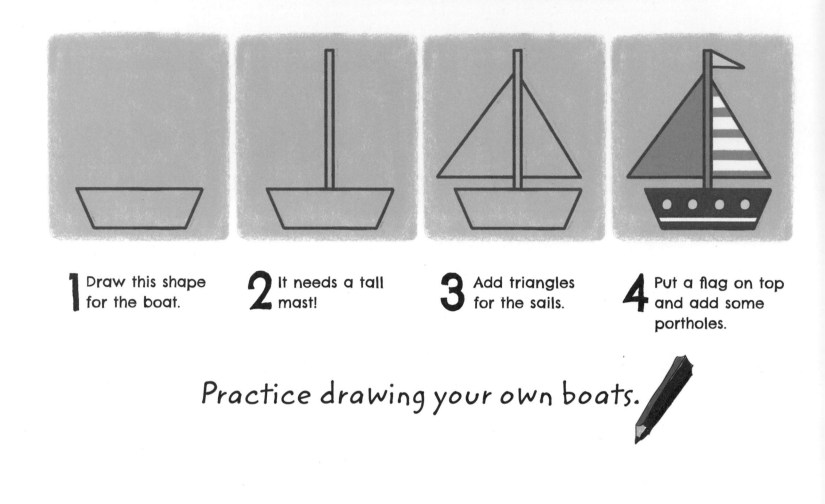

1 Draw this shape for the boat.

2 It needs a tall mast!

3 Add triangles for the sails.

4 Put a flag on top and add some portholes.

Practice drawing your own boats.

Can you draw some boats on the lake?

Mind the ducks!

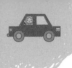

Let's draw a car!

1 Let's start with the wheels.

2 The body comes next.

3 Now add the windows.

4 Don't forget the driver!

Practice drawing some cars here.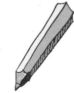

Can you fill the roads with cars?

On the Farm

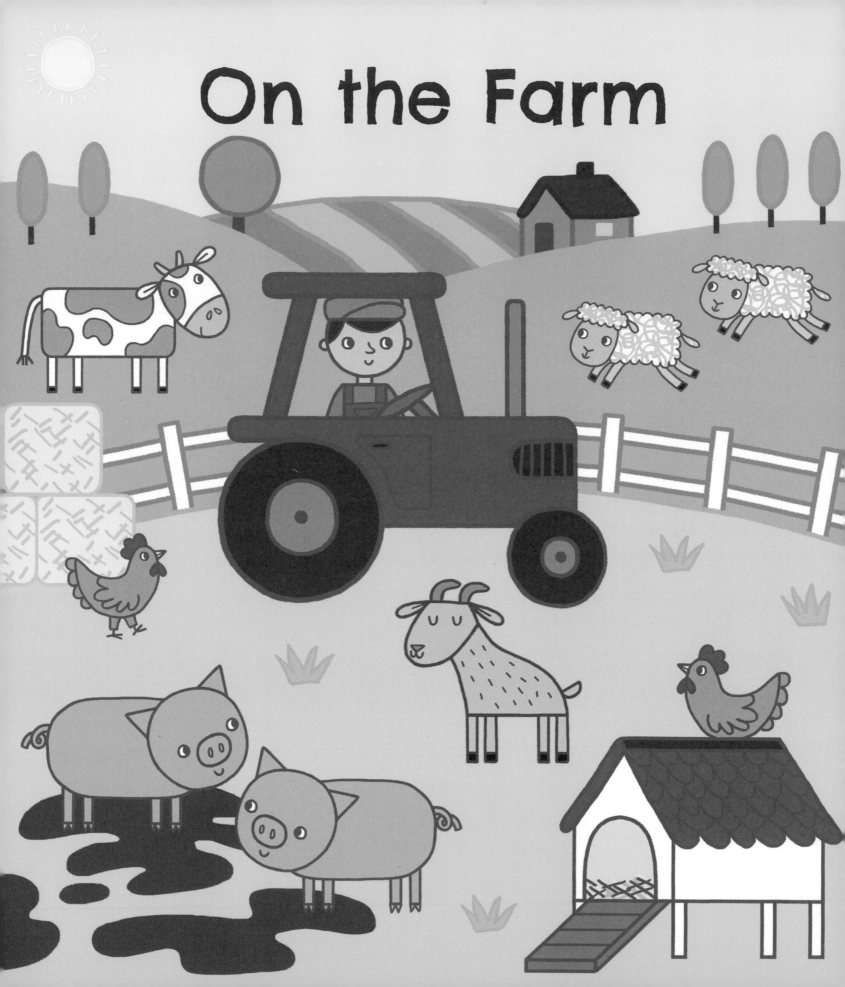

Can you draw a goat?

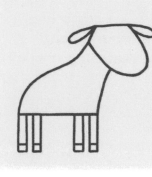

1 Here is her head.

2 Now draw her body.

3 Add her ears and legs.

4 Draw her face and two curly horns. Then, color her in.

Draw some goats here.

What about a pig?

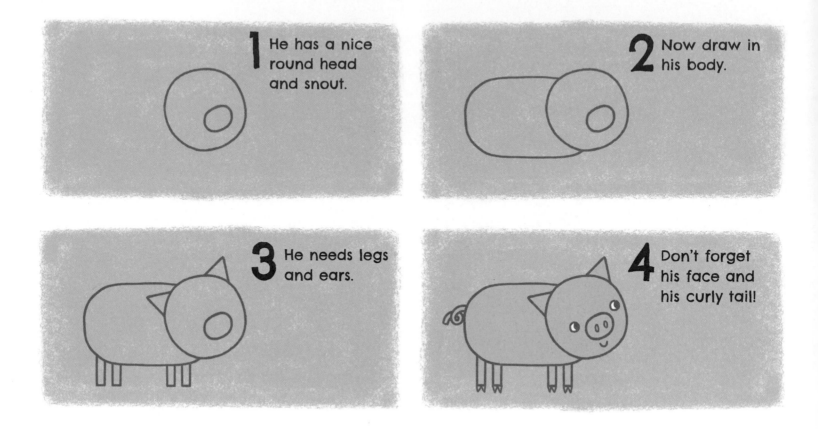

1 He has a nice round head and snout.

2 Now draw in his body.

3 He needs legs and ears.

4 Don't forget his face and his curly tail!

Practice drawing a pig.

A farm needs a farmer!

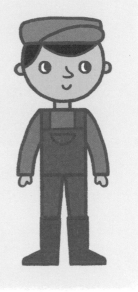

1 First draw his head.

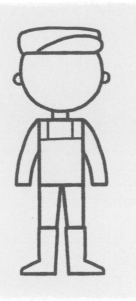

2 Now add a body, arms, and legs.

3 He needs some clothes!

4 Give him a face and some bright red boots!

You can choose different colors.

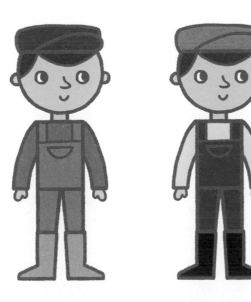

Now you try!

Let's draw a tractor.

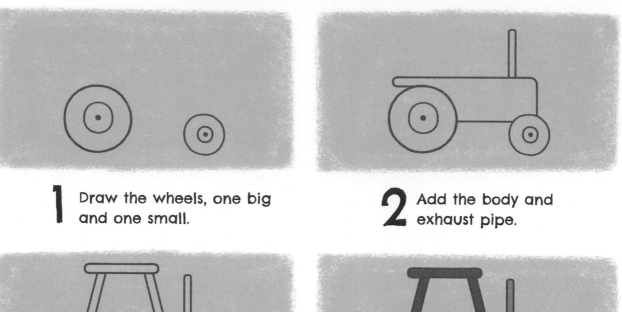

1 Draw the wheels, one big and one small.

2 Add the body and exhaust pipe.

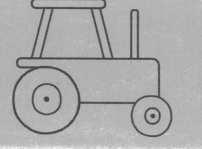

3 The farmer needs somewhere to sit!

4 Color the tractor bright red.

Now it's your turn!

Draw a tractor on the hill.

What animals are in the field?

Draw a wooly sheep.

1 Let's start with his head.

2 Add his body and ears.

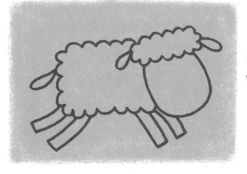

3 He needs legs and a little tail!

4 Give him a face and color in his wooly coat.

Now you have a try.

How many sheep are in the field?

Let's draw a chicken.

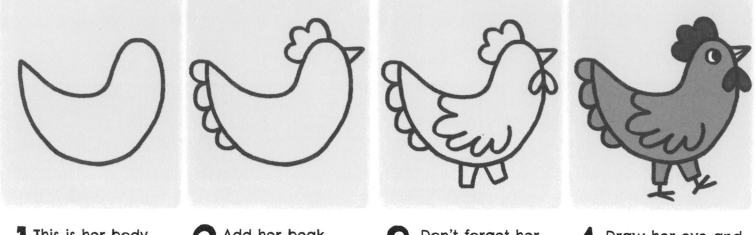

1 This is her body and head.

2 Add her beak and feathers.

3 Don't forget her legs and wing.

4 Draw her eye and feet. Color her in.

Try drawing some chickens here!

Draw some chickens around the hen house.

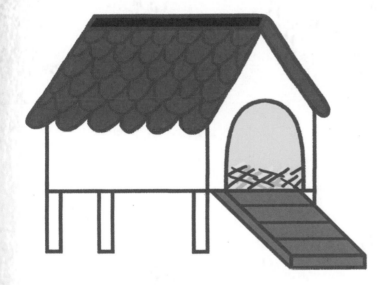

Have they laid any eggs?

How about a cow?

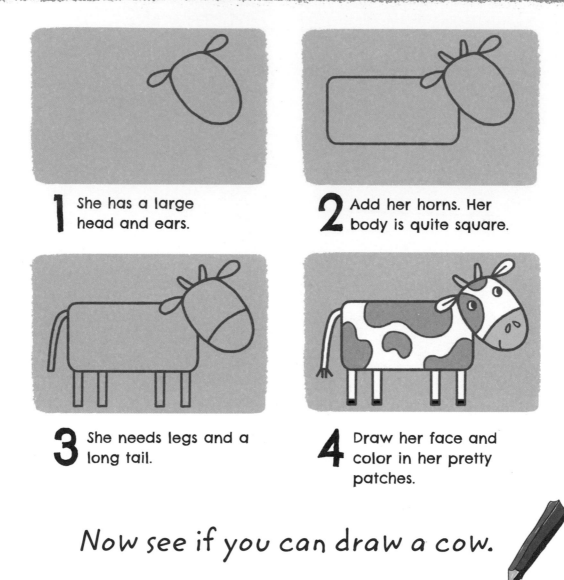

1 She has a large head and ears.

2 Add her horns. Her body is quite square.

3 She needs legs and a long tail.

4 Draw her face and color in her pretty patches.

Now see if you can draw a cow.

Can you draw some animals in the farmyard?

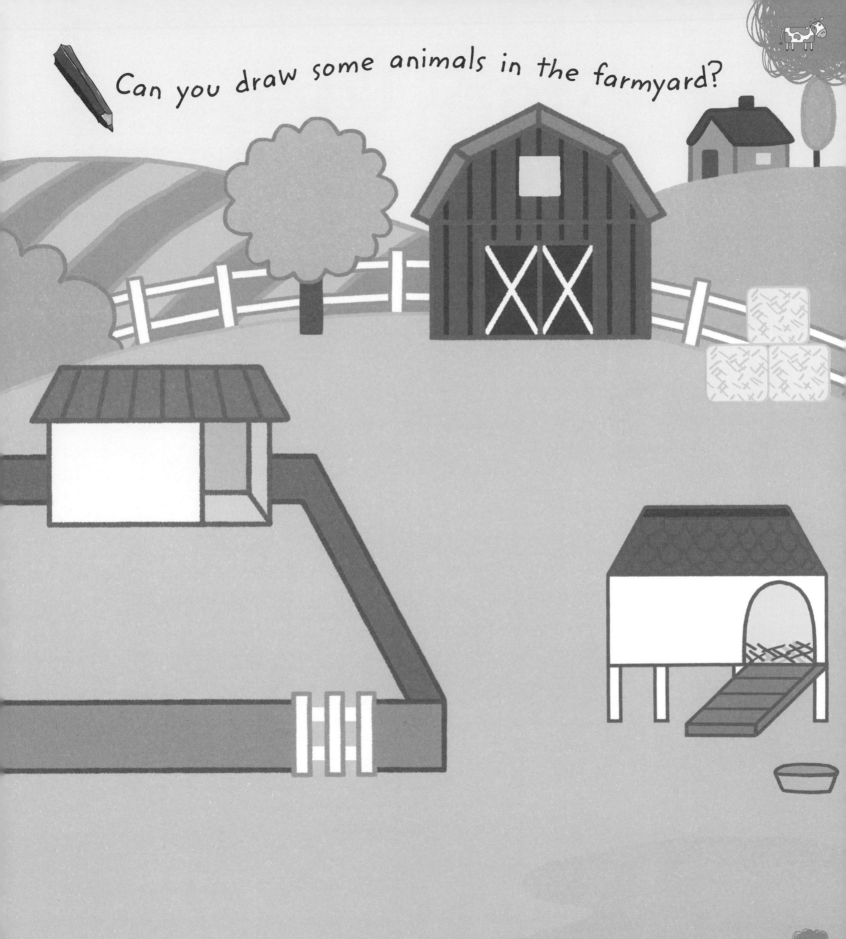

Story Land

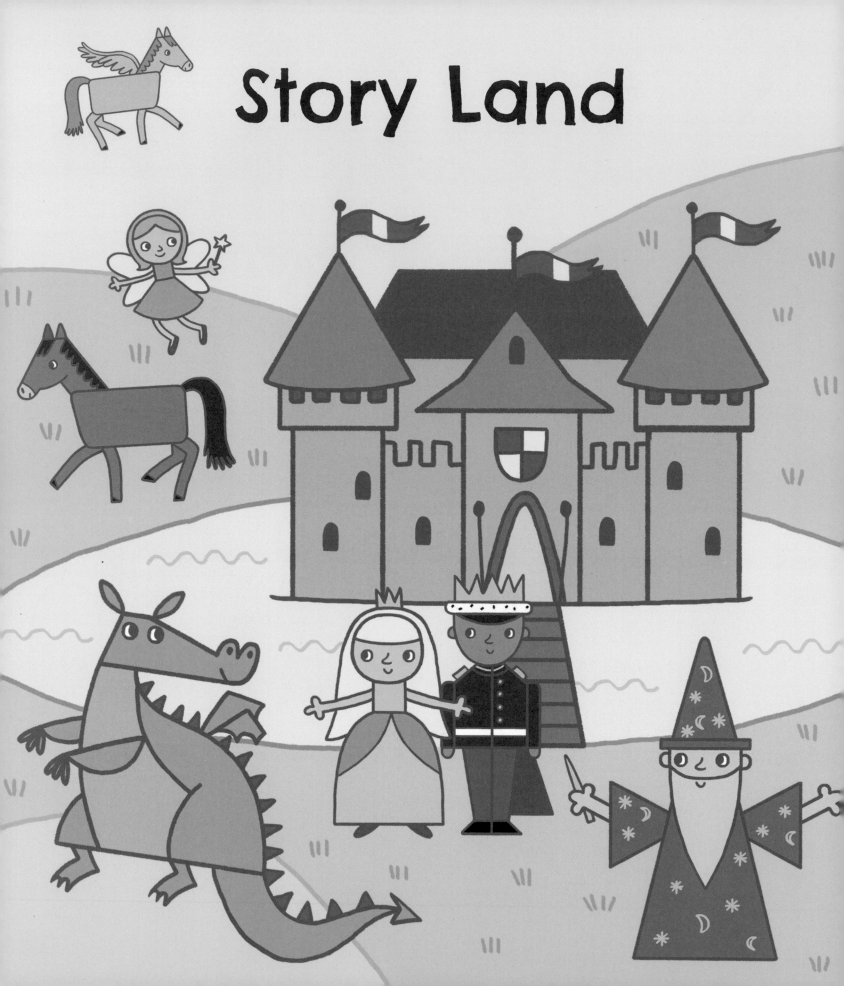

Let's start with a dragon!

1 Draw his long head.

2 Give him a body and ears.

3 Add shapes for his legs and wings. Don't forget his tail!

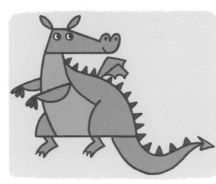

4 Draw his face, feet, and spines and color him in. Does he look fierce?

Draw your dragon here.

You will need a prince...

 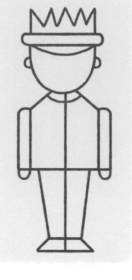 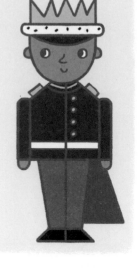

1 Start with his head and body.

2 Draw in his arms and legs.

3 Don't forget details like his crown!

4 He looks very handsome.

Practice drawing a prince.

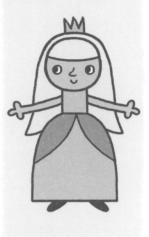

...and a pretty princess!

1 Draw her body and give her a round head.

2 She needs a long dress.

3 Draw her pretty hair and arms.

4 Add her face and crown. Now she's ready for the ball!

Try different colors...

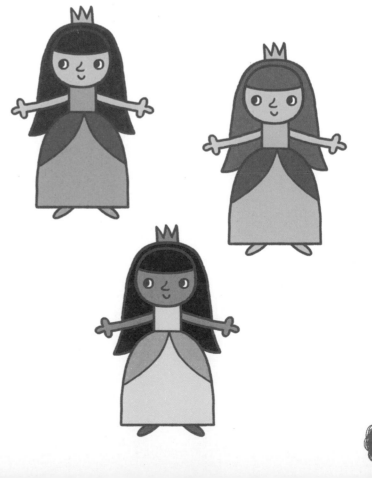

Can you draw a unicorn?

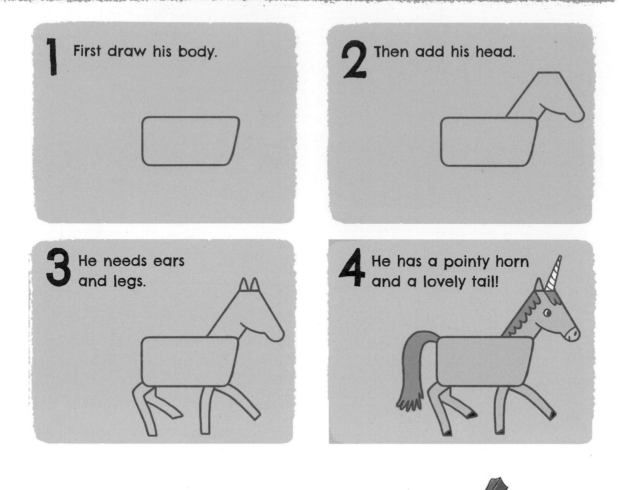

1 First draw his body.

2 Then add his head.

3 He needs ears and legs.

4 He has a pointy horn and a lovely tail!

Now you have a try!

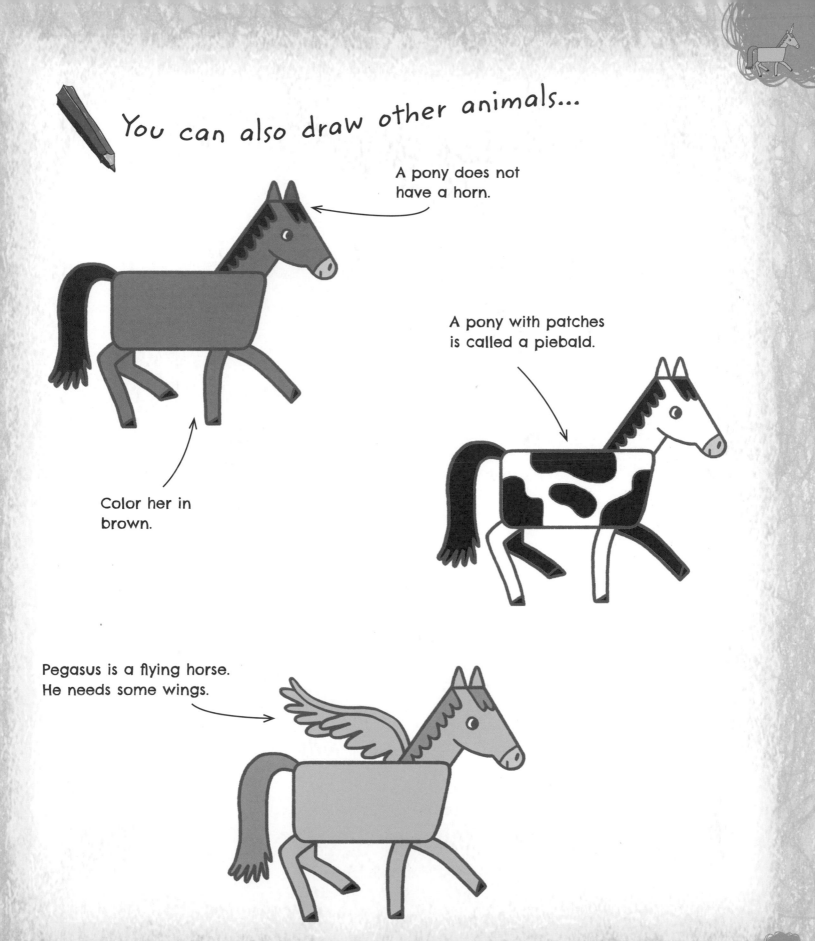

You can also draw other animals...

A pony does not have a horn.

A pony with patches is called a piebald.

Color her in brown.

Pegasus is a flying horse. He needs some wings.

Draw a brave knight.

1 Let's start with his helmet.

2 He needs a shield.

3 Draw his shiny armor.

4 Add his face, legs, and sharp sword!

Now you try.

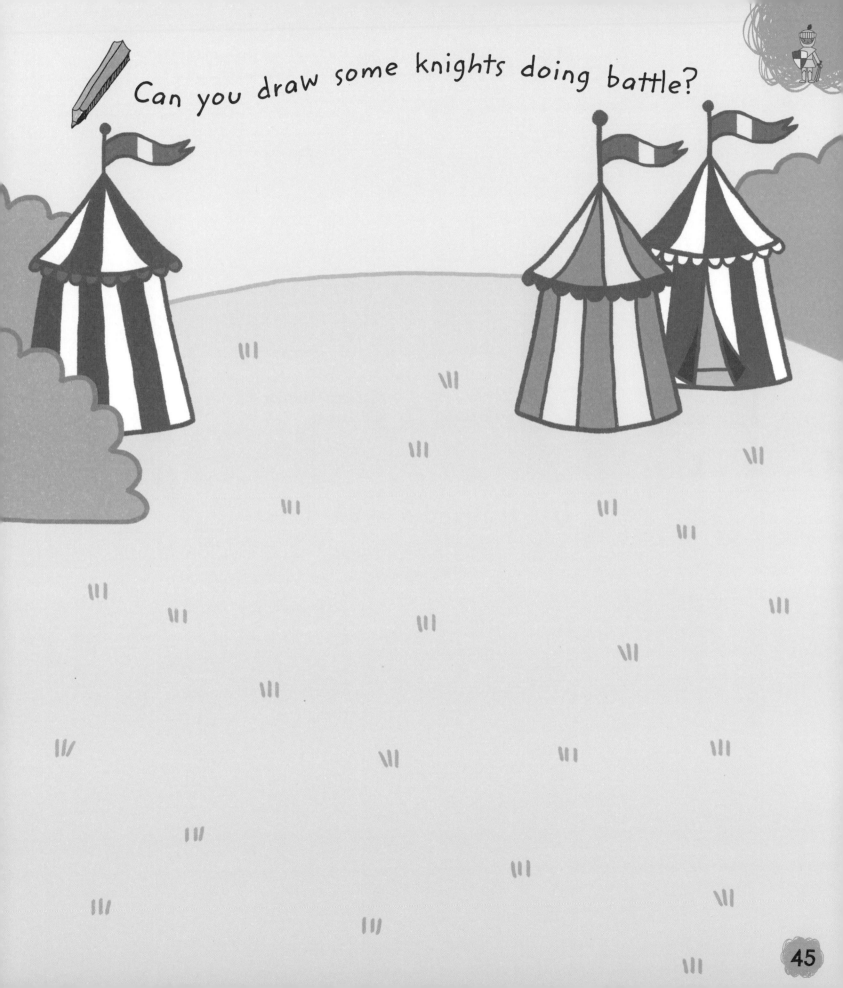

Can you draw some knights doing battle?

45

Let's draw a wizard.

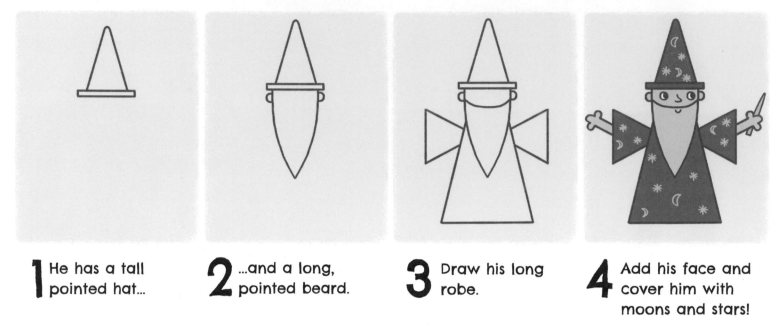

1 He has a tall
pointed hat...

2 ...and a long,
pointed beard.

3 Draw his long
robe.

4 Add his face and
cover him with
moons and stars!

Try drawing a wizard here!

 Draw a wizard casting a spell!

What kind of spell is it?

Draw a magical fairy.

1 First draw her head and dress.

2 She has a pretty hairstyle.

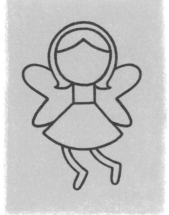

3 Every fairy needs legs and wings, of course!

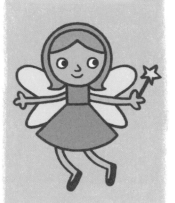

4 Add her arms and don't forget her wand! Color her in.

Can you draw a fairy?

Can you draw some fairies in the fairy glade?

Pets

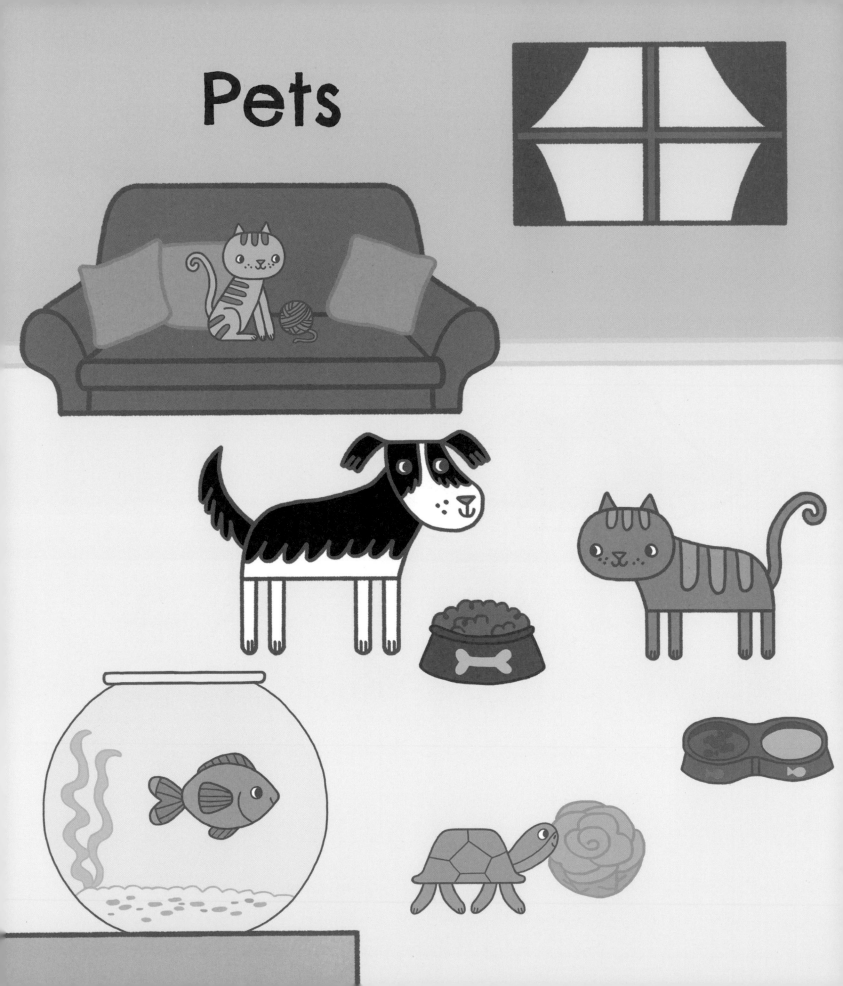

Draw a bunny rabbit!

1 Draw her head and long ears.

2 Now give her a body and one leg.

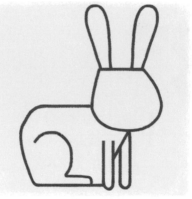

3 Add shapes for the rest of her legs.

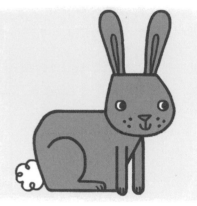

4 She has a cute face and a fluffy white tail!

Practice drawing a rabbit here.

Shall we draw a dog?

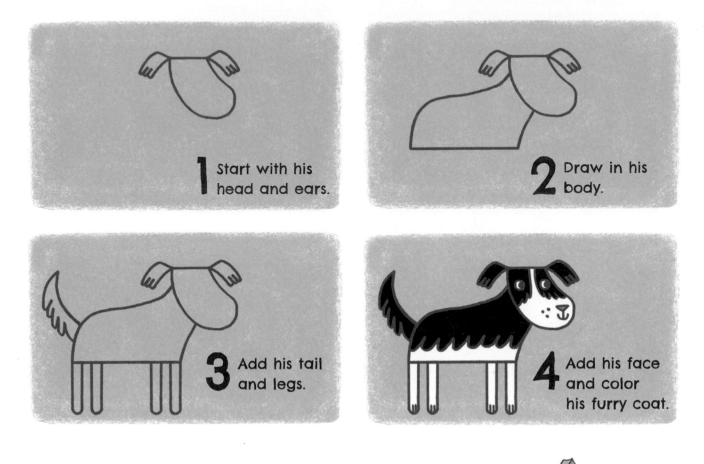

1 Start with his head and ears.

2 Draw in his body.

3 Add his tail and legs.

4 Add his face and color his furry coat.

Now it's your turn!

What kind of dog is Emily taking for a walk?

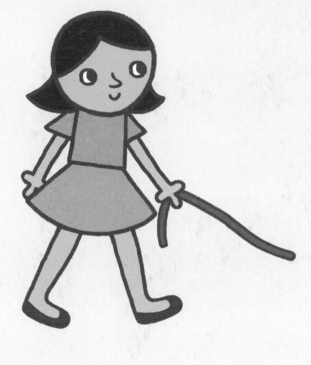

Can you draw more dogs in the park?

Let's draw a cute cat!

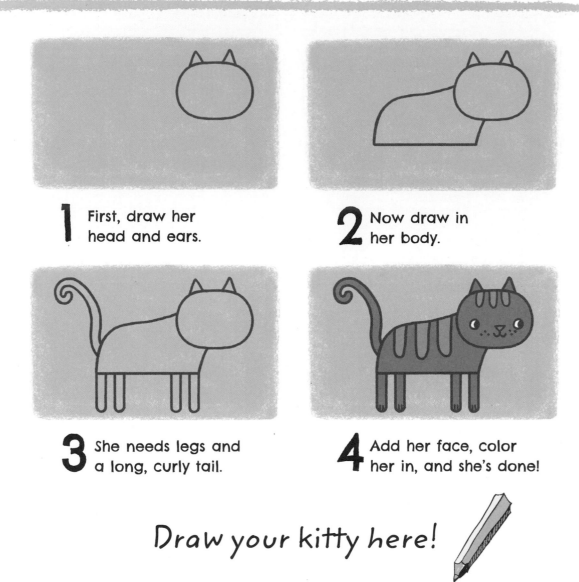

1 First, draw her head and ears.

2 Now draw in her body.

3 She needs legs and a long, curly tail.

4 Add her face, color her in, and she's done!

Draw your kitty here!

Can you draw a cat sitting down?

1 Start with her head again.

2 Her body looks a bit different.

3 Add her front legs and tail.

4 There, she's finished!

This tabby cat has a toy mouse.

This cat is black and white.

This gray cat has a ball of yarn.

You can draw lots of different cats!

What about a turtle?

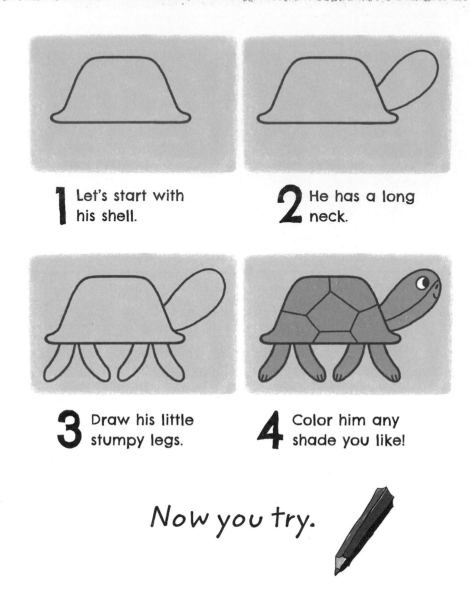

1 Let's start with his shell.

2 He has a long neck.

3 Draw his little stumpy legs.

4 Color him any shade you like!

Now you try.

Draw some turtles in the garden.

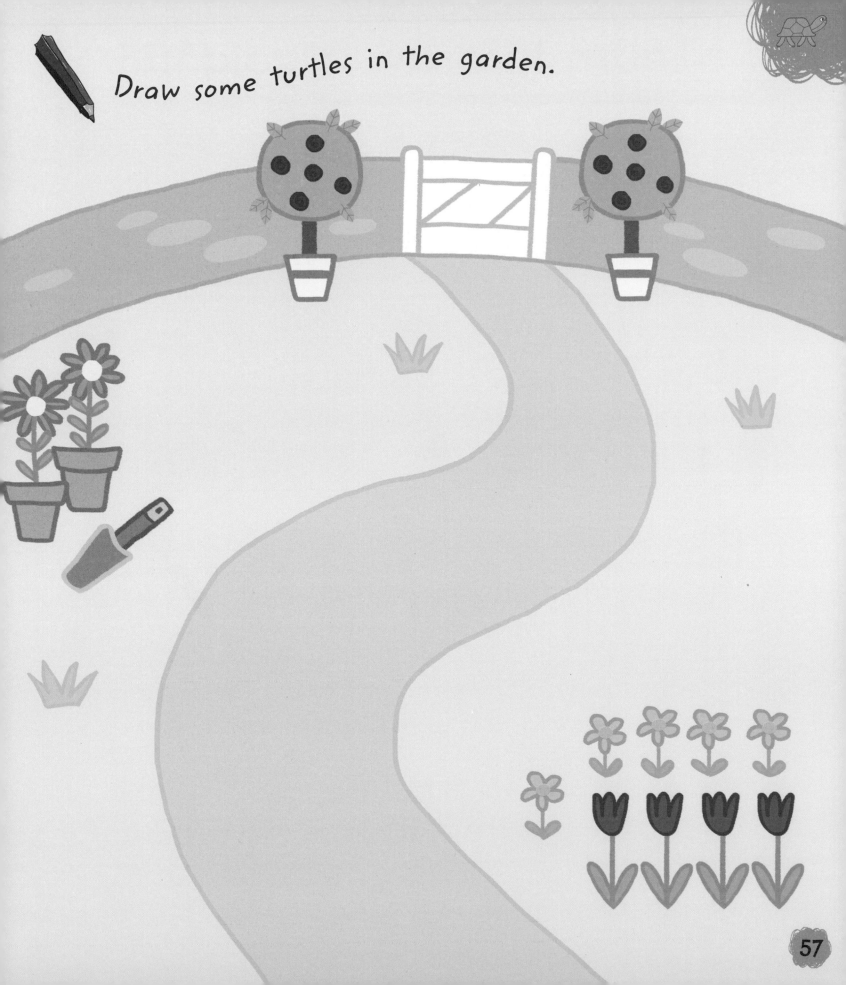

Learn to draw a goldfish!

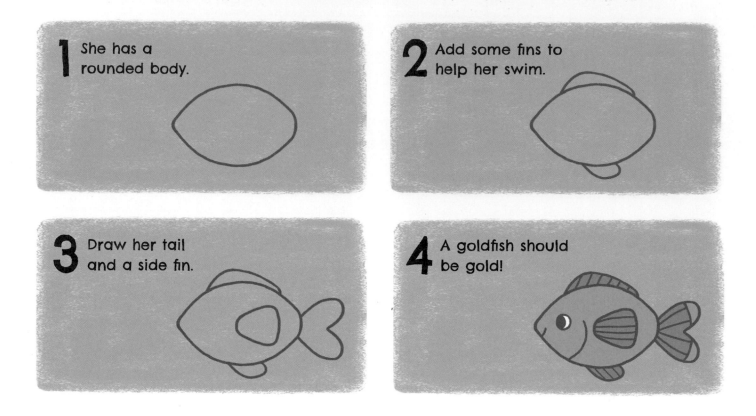

1 She has a rounded body.

2 Add some fins to help her swim.

3 Draw her tail and a side fin.

4 A goldfish should be gold!

Try drawing a goldfish here!

Draw some goldfish in the fish bowl!

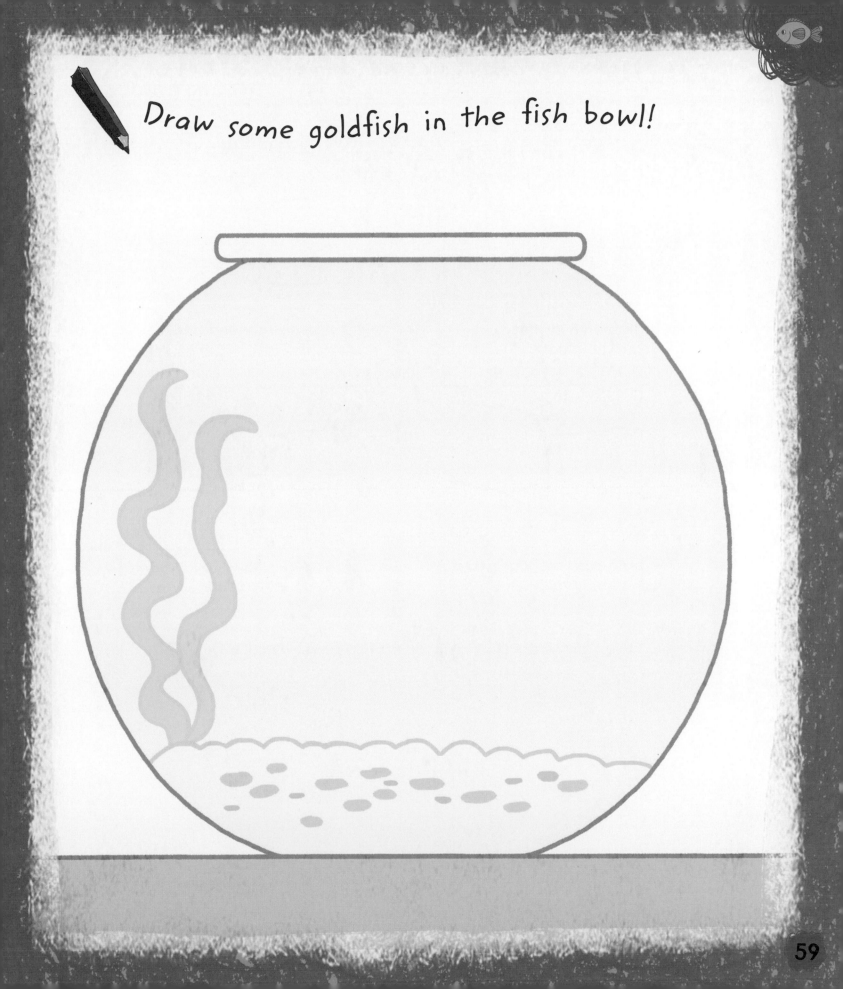

Let's draw a hamster.

1 Start with his head and little ears.

2 Add his rounded body.

3 He has little legs and a stumpy tail.

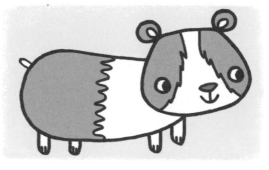

4 Draw his face and color in his fluffy coat!

Try drawing a hamster here.

Can you draw a hamster in his wheel?

Draw a parakeet.

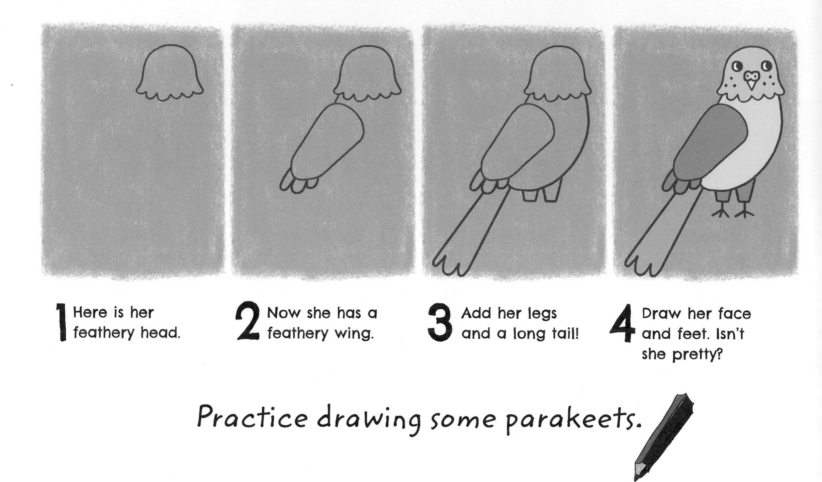

1 Here is her feathery head.

2 Now she has a feathery wing.

3 Add her legs and a long tail!

4 Draw her face and feet. Isn't she pretty?

Practice drawing some parakeets.

Draw the pets eating their food.

Under the Sea

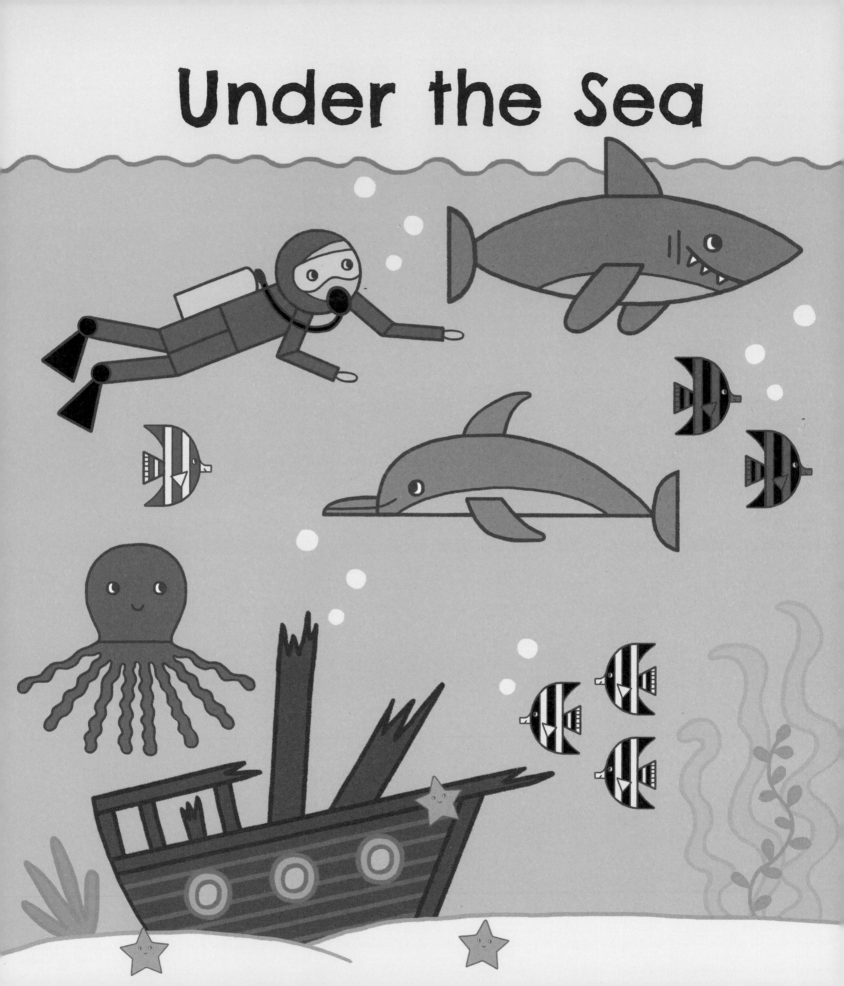

Draw a deep-sea diver

1 Start with his head and body.

2 Then draw some shapes for his arms and legs.

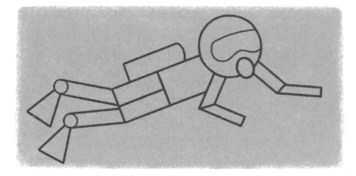

3 Finish his arms. He needs flippers, a mask, and an air tank!

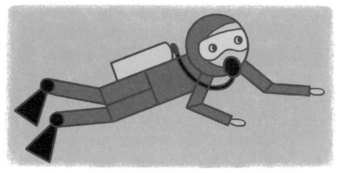

4 Add his hands and eyes. Color him in and don't forget his breathing tube!

Can you draw a diver here?

Let's draw a tropical fish!

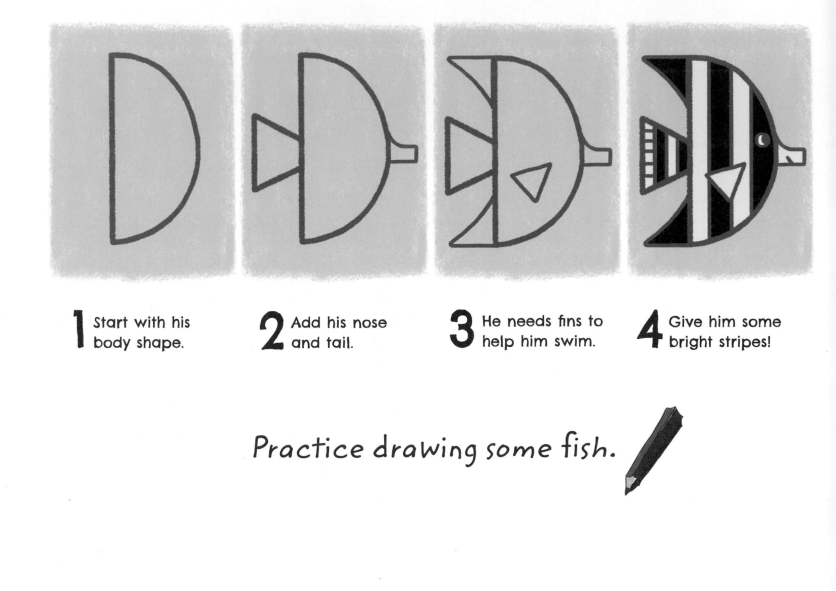

1 Start with his body shape.

2 Add his nose and tail.

3 He needs fins to help him swim.

4 Give him some bright stripes!

Practice drawing some fish.

Tropical fish come in lots of different colors...

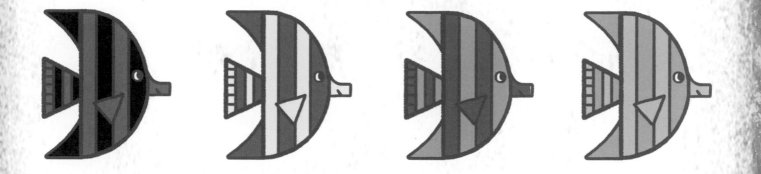

Can you draw a shoal of pretty fish?

Now try a shark!

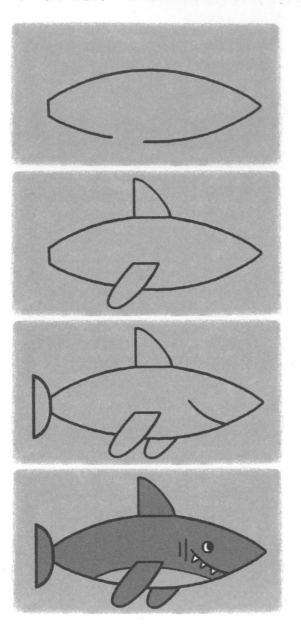

1 First draw this shape for his body.

2 Then, draw in some fins.

3 He needs a tail and a smiley mouth.

4 Don't forget his face and those sharp teeth when you color him in!

Not all sharks look so happy!

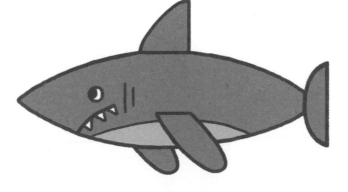

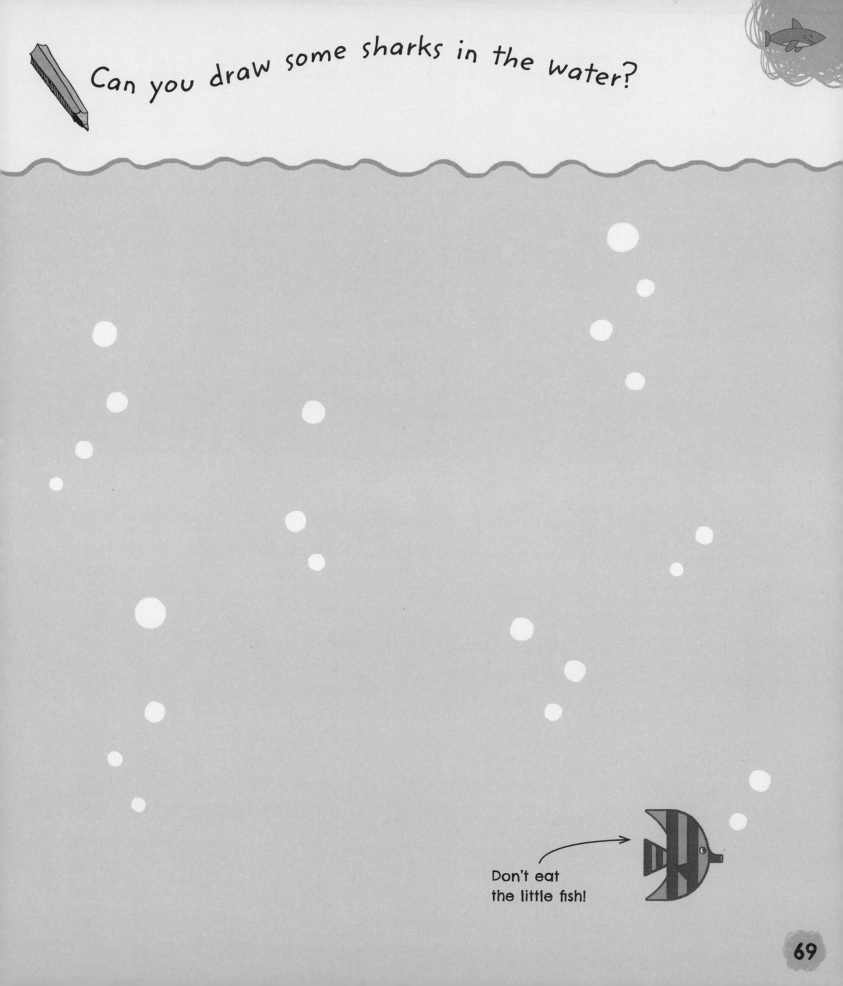

Can you draw some sharks in the water?

Don't eat the little fish!

69

What about an octopus?

 1 Start with his head.

2 Draw his two outer legs.

 3 He needs six more legs!

4 Give him a smiley face and color in all those legs!

Now you have a try.

Can you draw an octopus on the seabed?

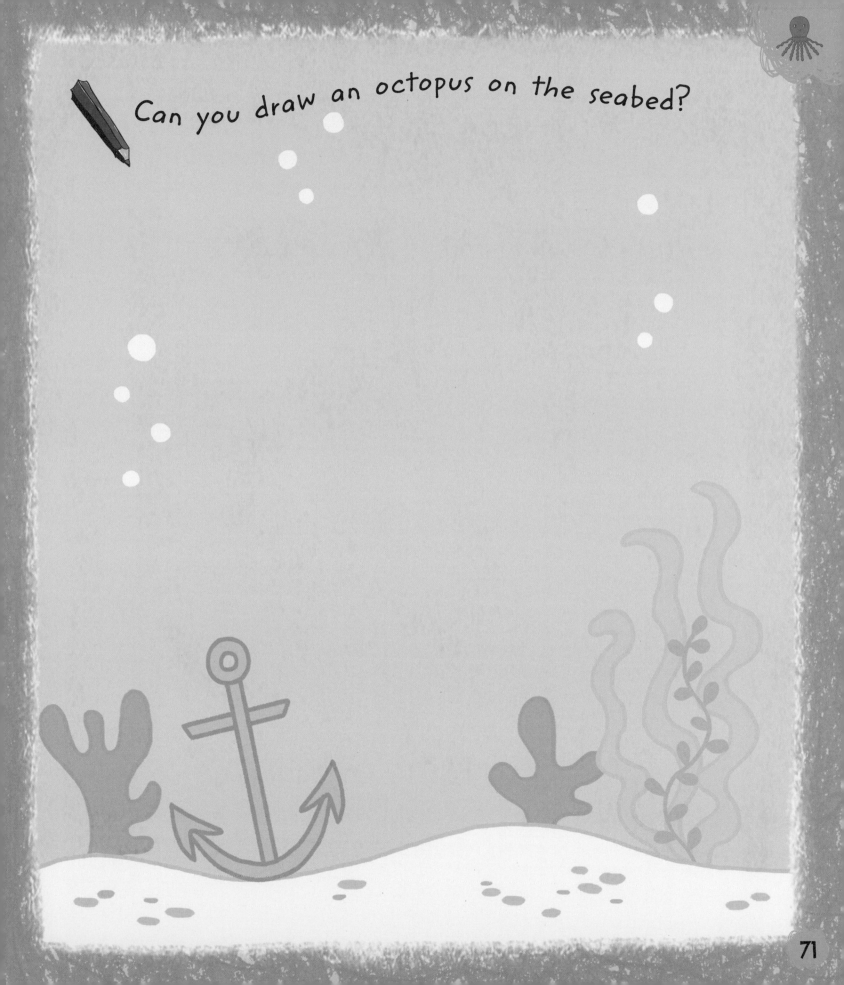

Learn to draw a dolphin...

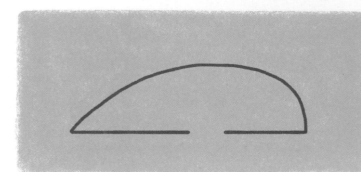

1 Start with a shape for her body.

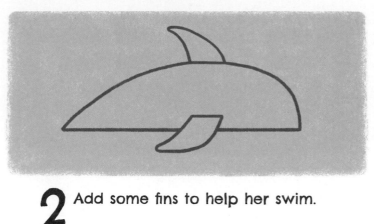

2 Add some fins to help her swim.

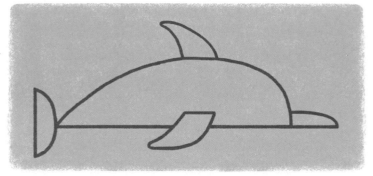

3 Draw her tail and a long nose.

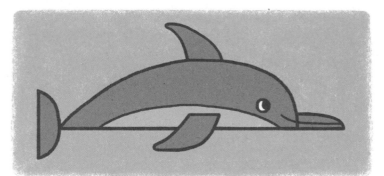

4 Add her smiley face and color her in. Now she's ready for a swim!

Try drawing a dolphin here.

...and a whale!

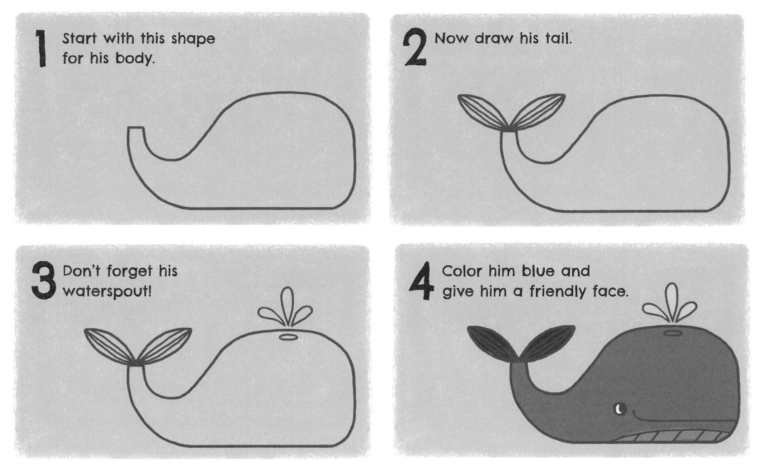

1 Start with this shape for his body.

2 Now draw his tail.

3 Don't forget his waterspout!

4 Color him blue and give him a friendly face.

Practice drawing a whale.

Let's draw a starfish.

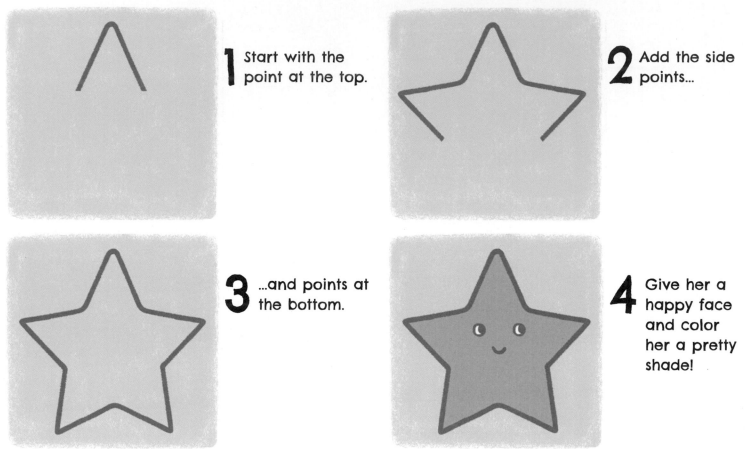

1 Start with the point at the top.

2 Add the side points...

3 ...and points at the bottom.

4 Give her a happy face and color her a pretty shade!

Now it's your turn!

Can you fill the scene with sea creatures?

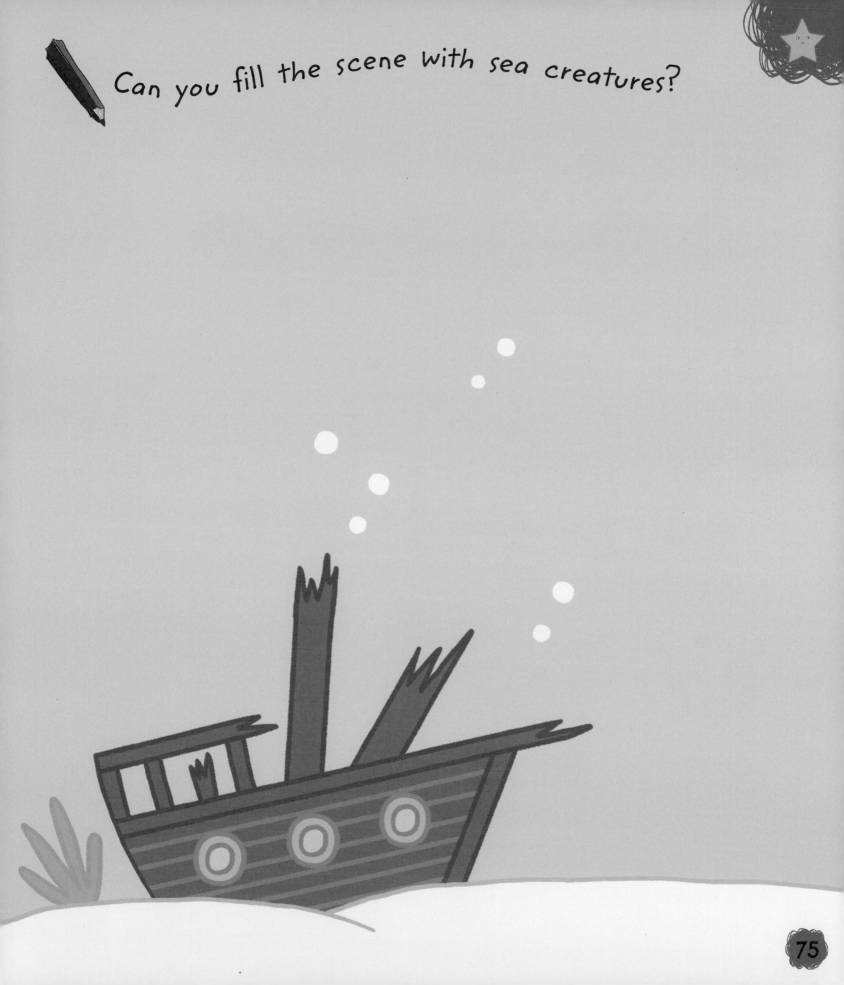

Dinosaurs

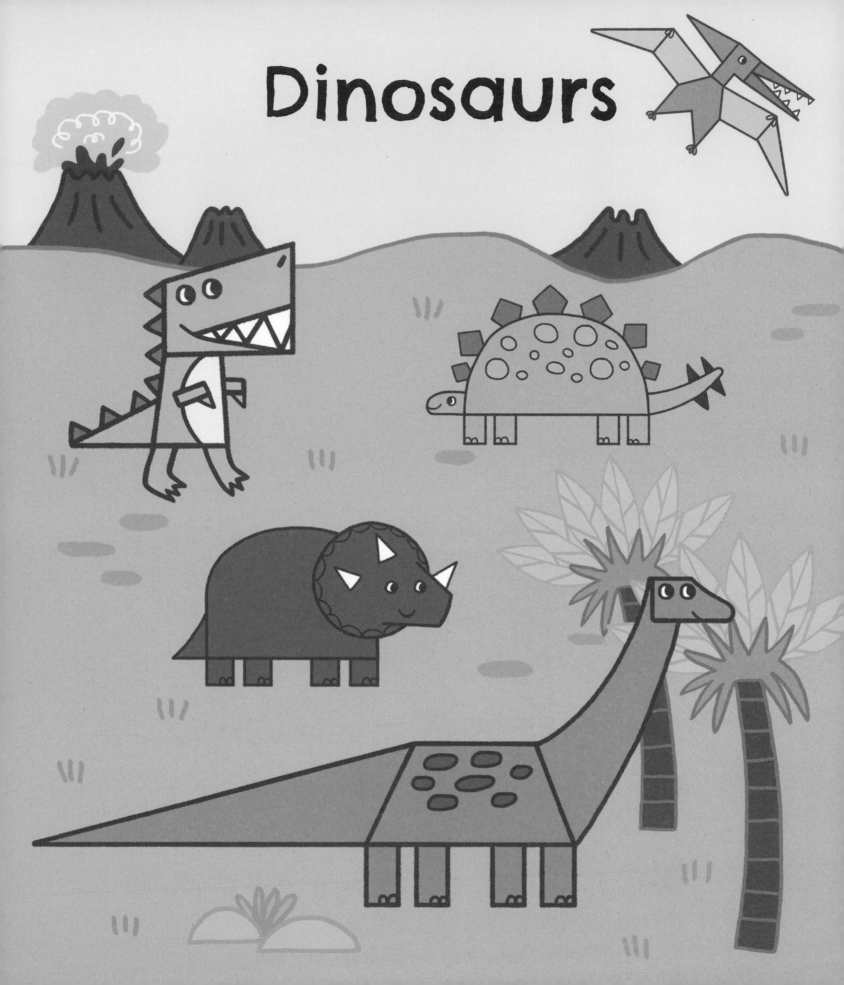

Can you draw a T. rex?

1 Start with his head and body.

2 He needs a mouth, a tail, and feet.

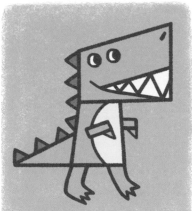

3 Don't miss his little arms, sharp teeth, and spines!

4 Add the final details and color him in. Does he look very fierce?

Practice drawing your T. rex here!

Let's try a Triceratops.

1 Begin with this shape for her head.

2 Add her body. She's quite big, isn't she?

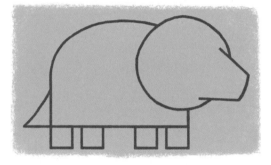

3 Draw her tail and her little stumpy legs.

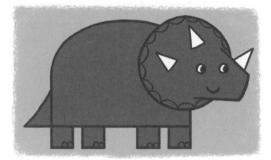

4 Add her face and color her in. She has three horns!

Now you draw a Triceratops.

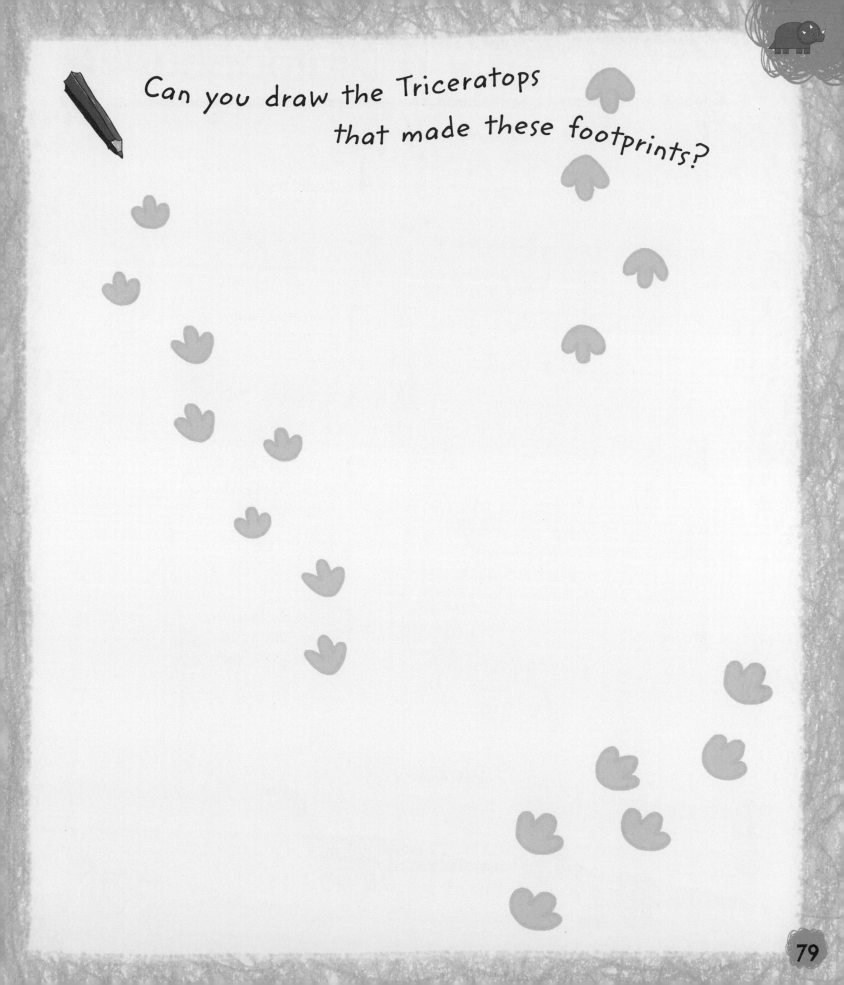

Can you draw the Triceratops that made these footprints?

Now draw a Diplodocus!

1 First, draw this shape for his body.

2 Then add four strong legs.

3 He has a little head, a long neck, and a huge tail.

4 Draw his face and color him in. We gave him purple spots!

What color is your Diplodocus?

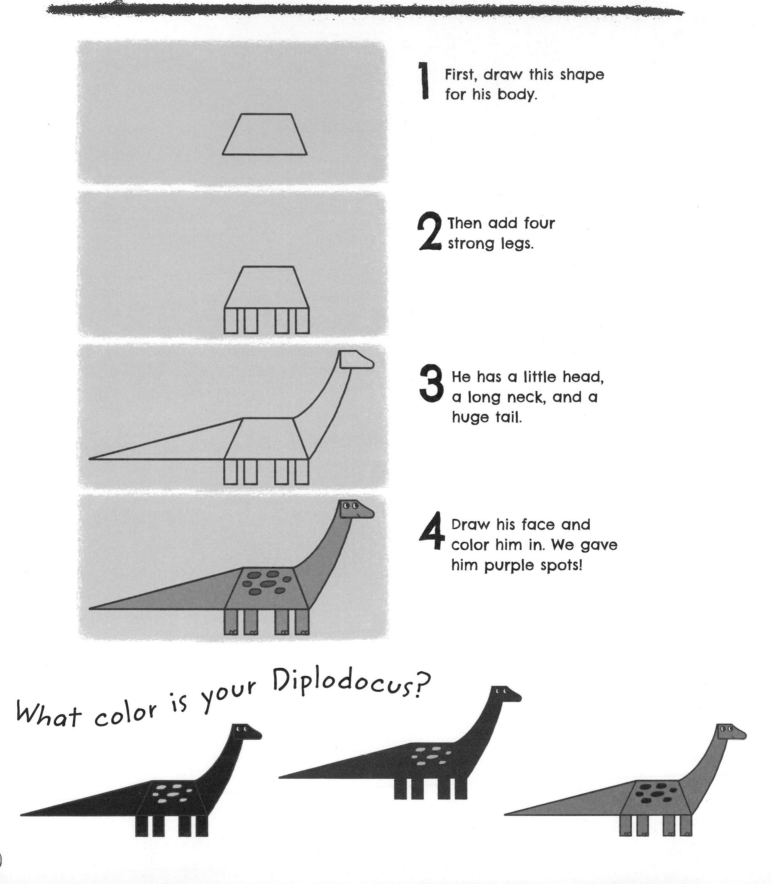

Draw a Diplodocus eating from the tree.

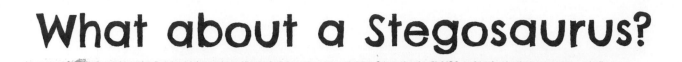

What about a Stegosaurus?

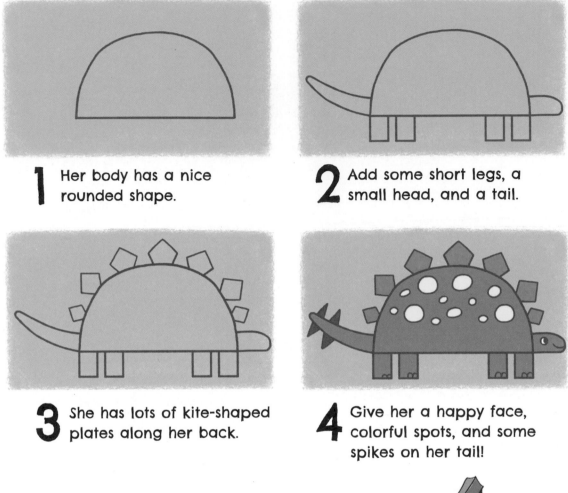

1 Her body has a nice rounded shape.

2 Add some short legs, a small head, and a tail.

3 She has lots of kite-shaped plates along her back.

4 Give her a happy face, colorful spots, and some spikes on her tail!

Now you have a try.

Can you draw the Stegosaurus that laid these eggs?

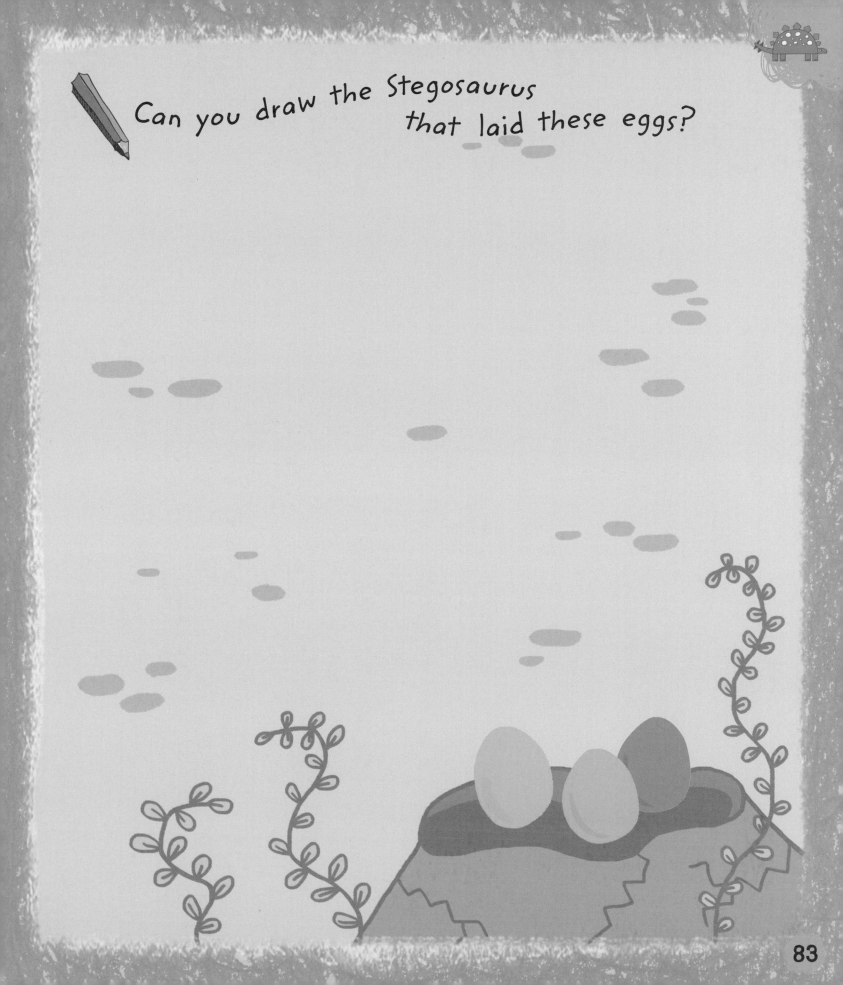

Draw a Pterodactyl.

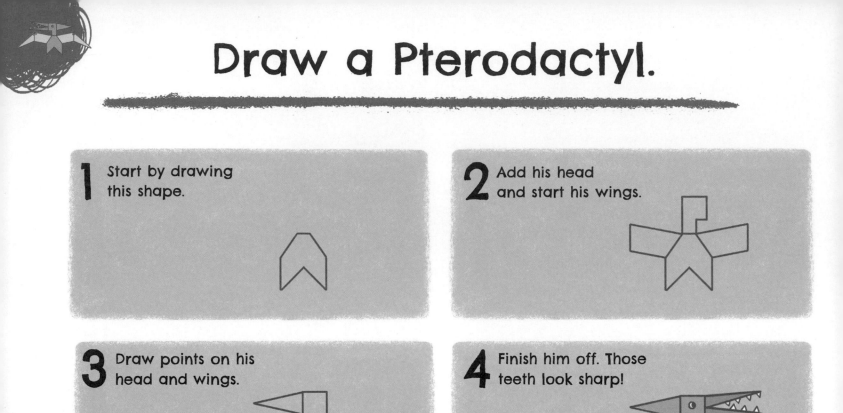

1 Start by drawing this shape.

2 Add his head and start his wings.

3 Draw points on his head and wings.

4 Finish him off. Those teeth look sharp!

Try drawing a Pterodactyl here.

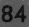

How many dinosaurs can you draw?

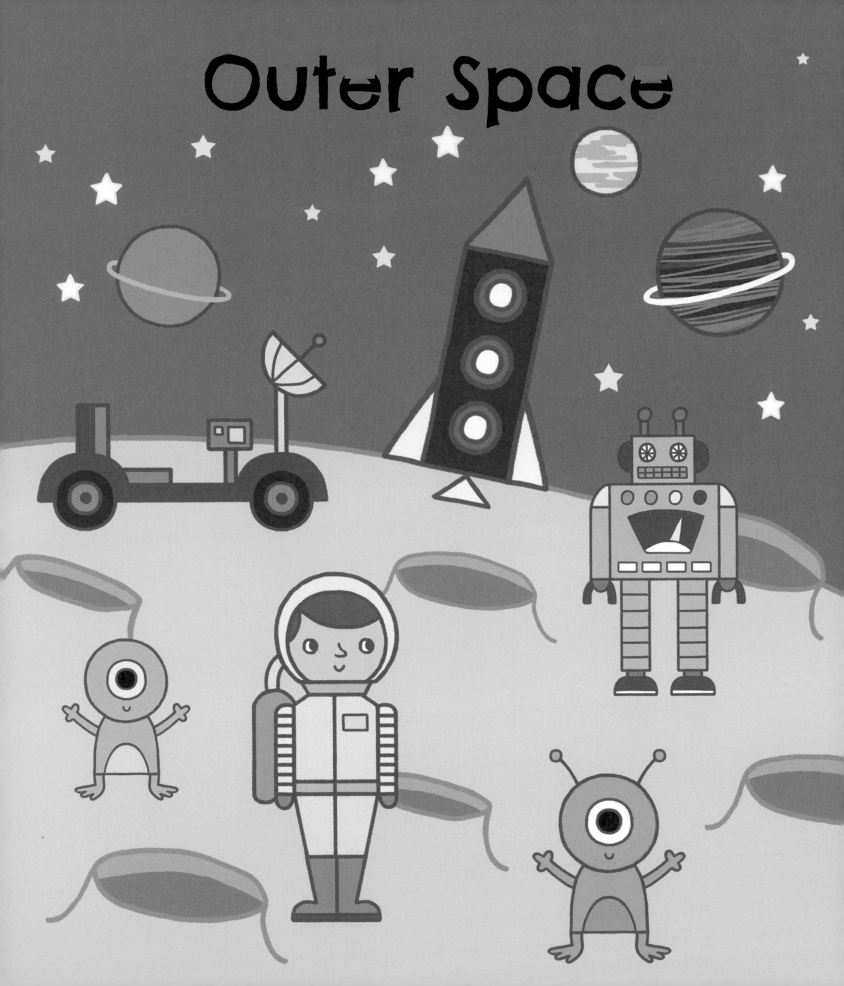

Let's start with a rocket.

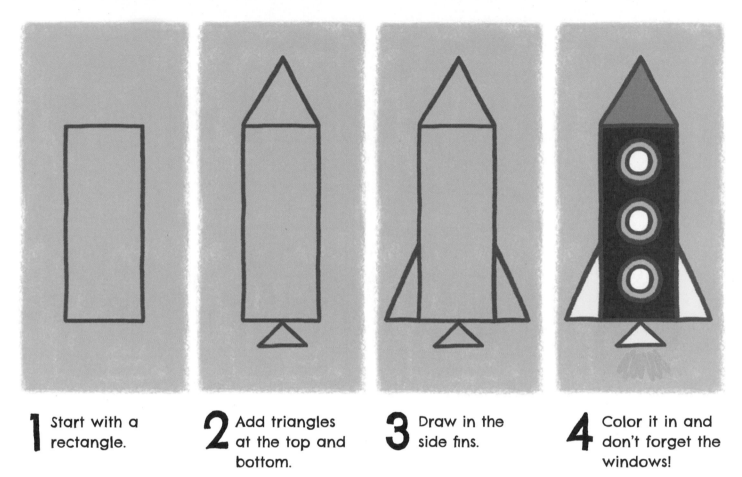

1 Start with a rectangle.

2 Add triangles at the top and bottom.

3 Draw in the side fins.

4 Color it in and don't forget the windows!

Practice drawing a rocket here!

Now draw an astronaut.

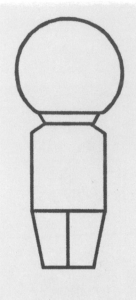 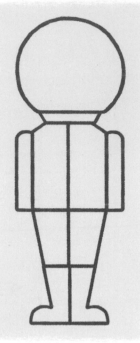

1 Begin with this helmet and body.

2 Draw his arms and his boots.

3 Add more details like an air tank and badge!

4 Draw his face and color him in. He looks very proud!

Now it's your turn!

Can you draw an astronaut in space?

Can you draw a robot?

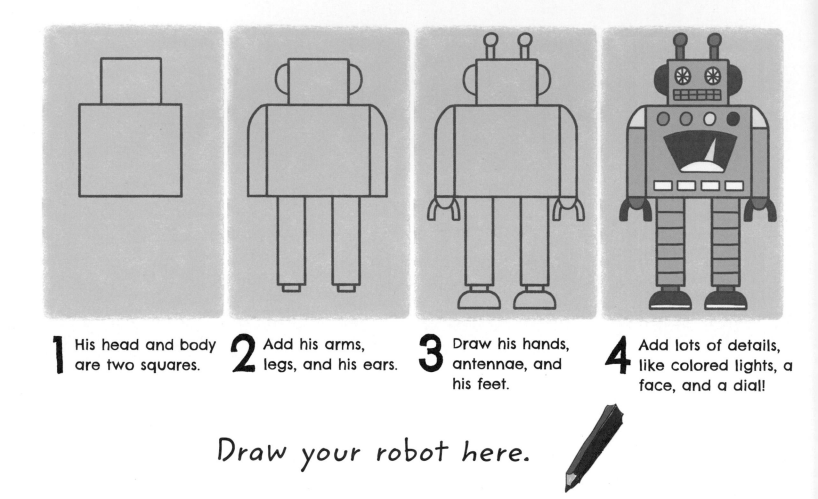

1 His head and body are two squares.

2 Add his arms, legs, and his ears.

3 Draw his hands, antennae, and his feet.

4 Add lots of details, like colored lights, a face, and a dial!

Draw your robot here.

You can draw robots using different shapes...

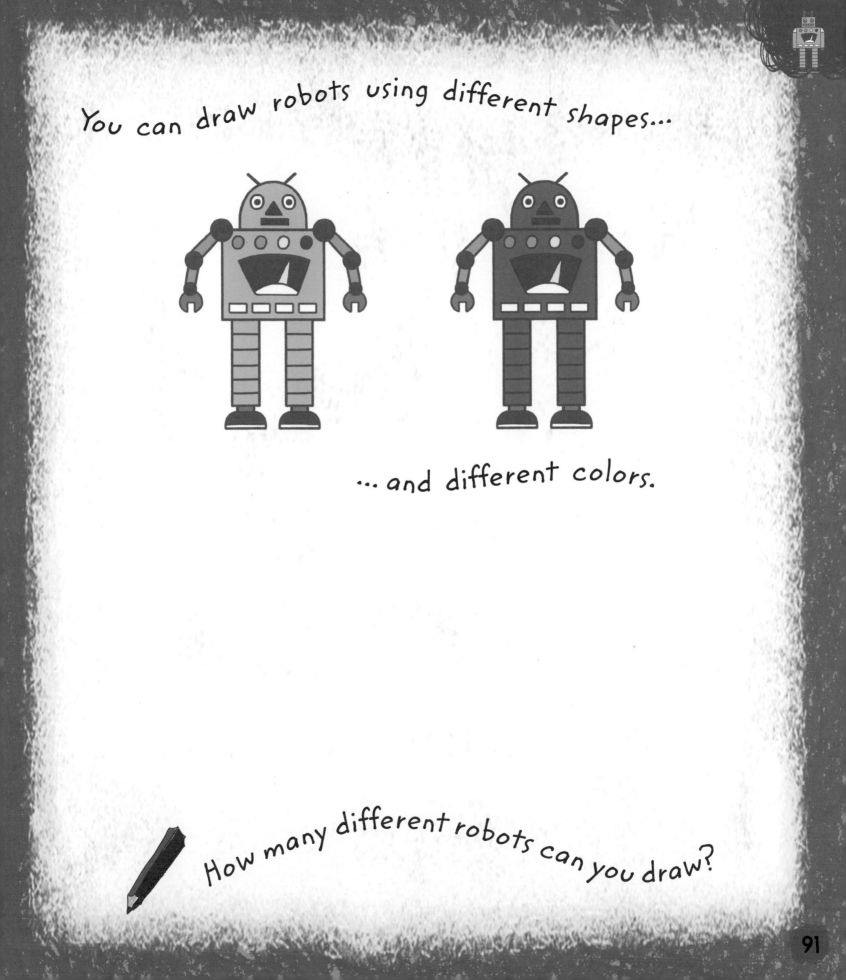

...and different colors.

How many different robots can you draw?

How about an alien?

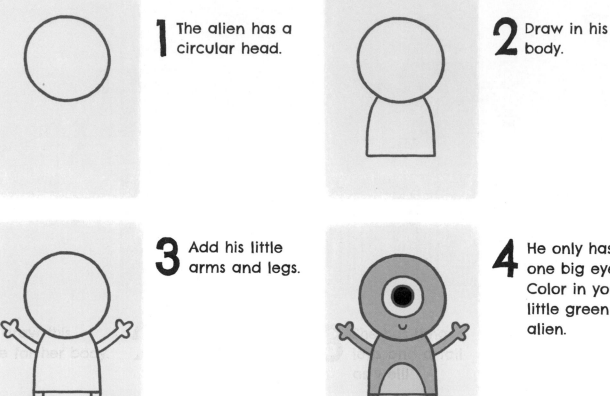

1 The alien has a circular head.

2 Draw in his body.

3 Add his little arms and legs.

4 He only has one big eye! Color in your little green alien.

Try drawing an alien here.

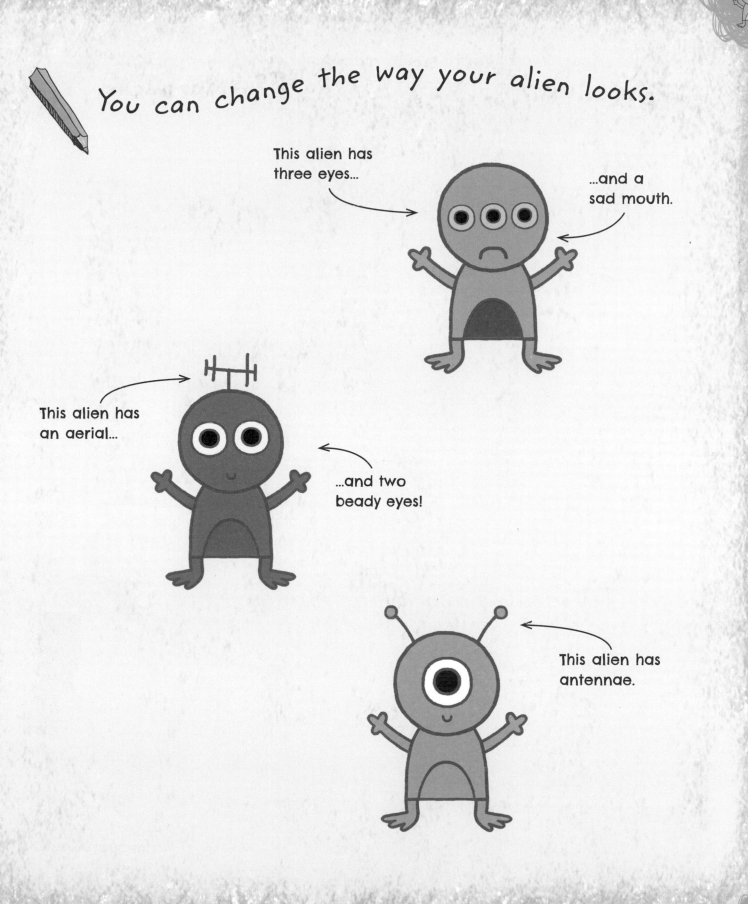

You can change the way your alien looks.

This alien has three eyes...

...and a sad mouth.

This alien has an aerial...

...and two beady eyes!

This alien has antennae.

Let's draw a moon buggy.

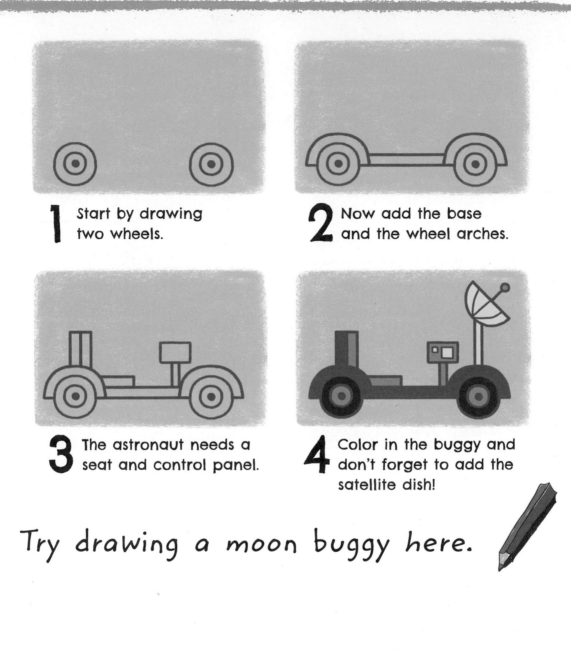

1 Start by drawing two wheels.

2 Now add the base and the wheel arches.

3 The astronaut needs a seat and control panel.

4 Color in the buggy and don't forget to add the satellite dish!

Try drawing a moon buggy here.

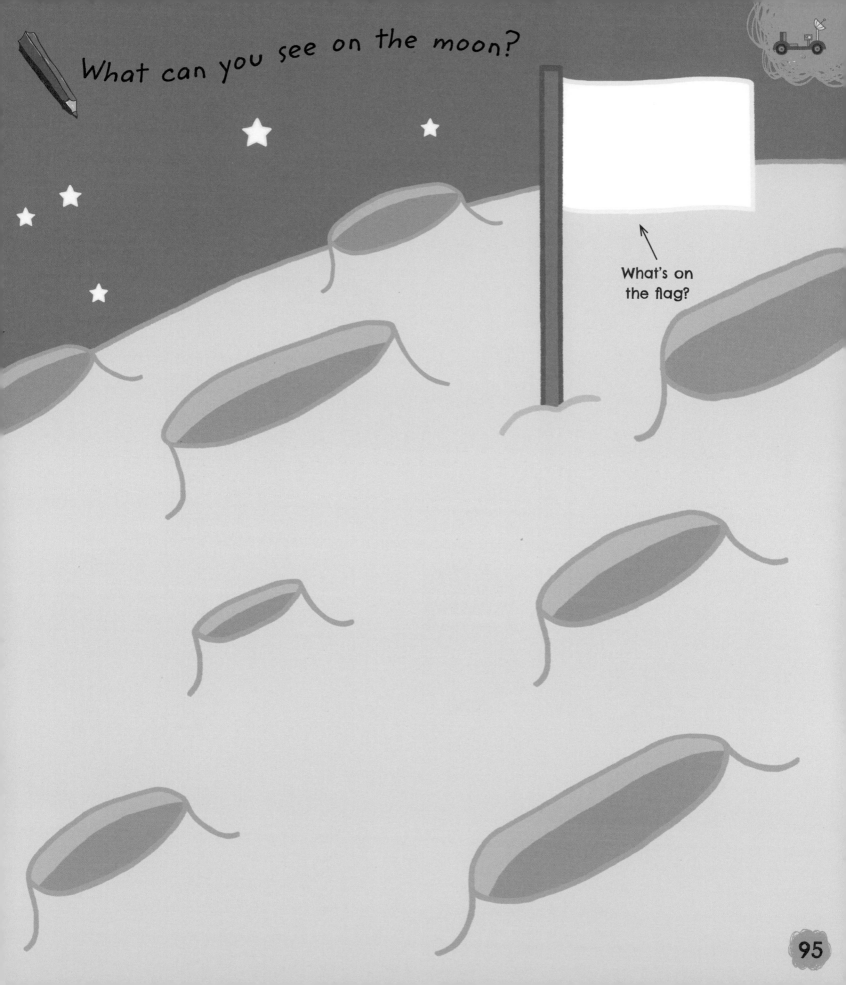

What can you see on the moon?

What's on the flag?

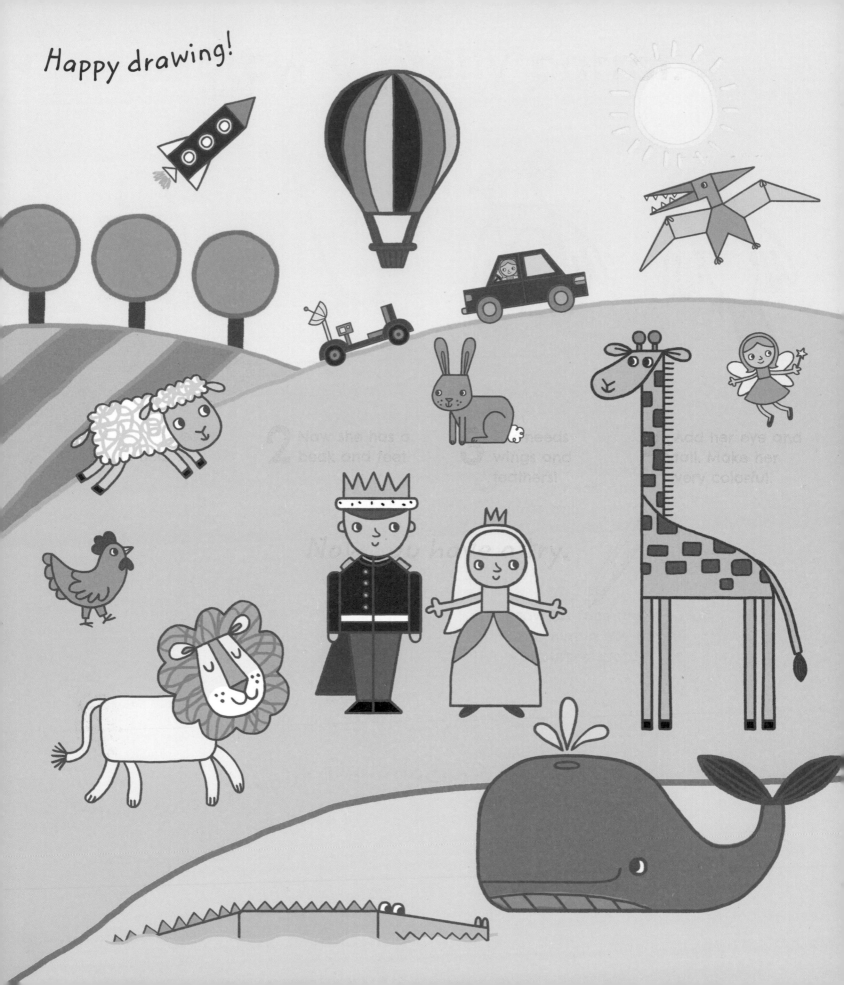

Happy drawing!